PEEL

THE ART OF
THE STICKER

MARK BATTY PUBLISHER

CONTENTS

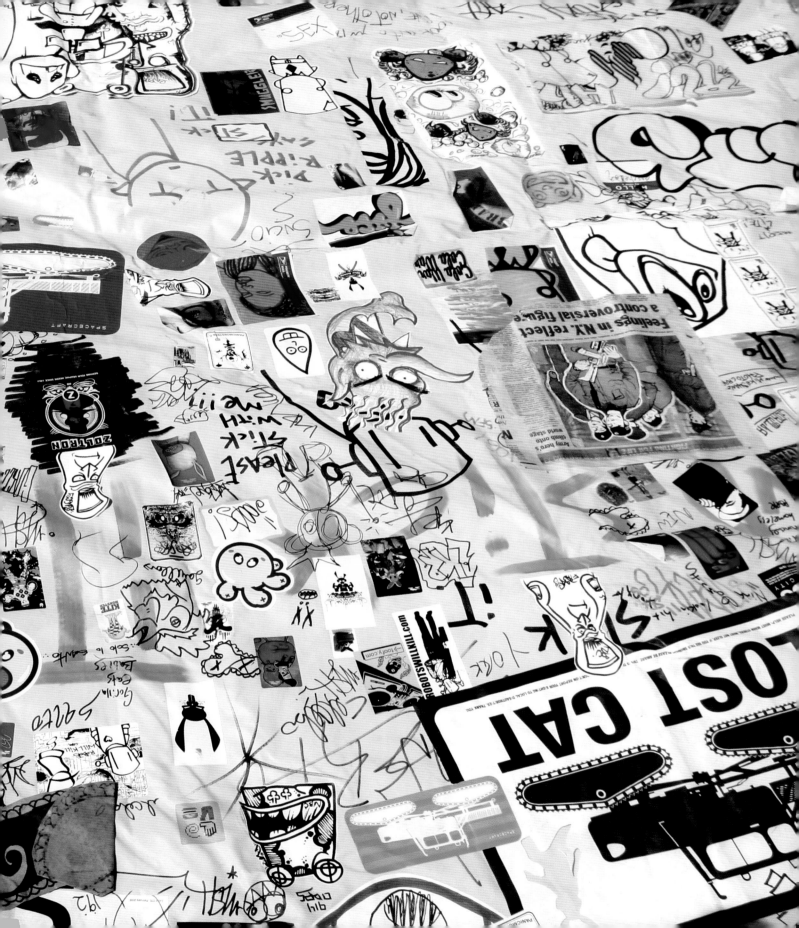

As of the publication of this book, PEEL Magazine has released 8 issues. Highlights from each issue – as identified by Dave and Holly Combs – have been grouped together. The individual issues appear chronologically and are separated by "Theme" sections.

Each of these sections showcases examples of a recurring motif found within several issues of PEEL Magazine.

Social/Political – Sticker-artists' visual opinions on modern sociopolitical issues

Characters – Recurring character(s) part of a particular sticker-artist's repertoire

PEEL – Artists' various renditions of the PEEL logo

Stencil, Spray & Drawings – Featured street art outside of stickers

Contests – PEEL-sponsored sticker contests in which artists submit designs the best of which are showcased in the magazine

Blackbook – In an effort to avoid corporate sponsorship, PEEL sets aside pages on which sticker-artists may pay a small fee to display their work.

Toys – Many sticker-artists have thrown their hat into the arena of toy design

Take your art and... STICK IT!

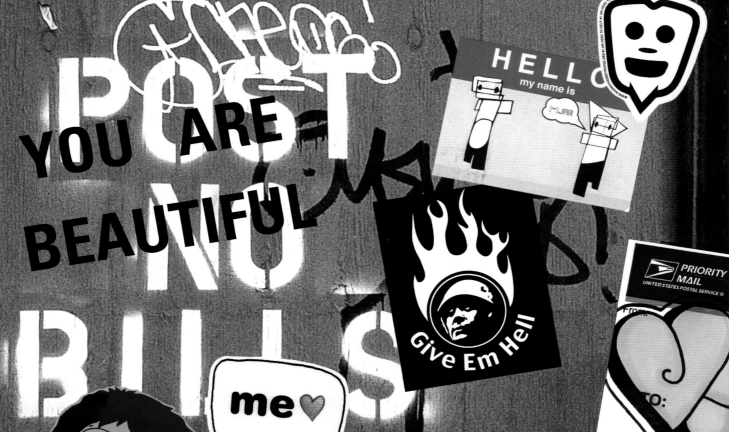

YOU ARE BEAUTIFUL

POST NO BILLS

ORIGINS OF A MAGAZINE: THE BIRTH OF PEEL

By Jon Udelson

The idea sparked on a winter day. Only a few months after Sept. 11, Dave and Holly Combs traveled with their church group from Indianapolis to New York City in order to assist with the still-massive Ground Zero clean-up. Walking the streets during their off hours, Dave and Holly took in the expansive cityscape. When Dave first happened upon a signpost stickered with the iconic face of Andre the Giant accompanied by the words "Andre the Giant Has a Posse" suspended to the right of the figure's head, he thought the image merely interesting. Andre the Giant was dead, and couldn't have a posse—it was good for a quick, ironic laugh. At the time Dave didn't think much of it, but when he started to see the sticker of the professional wrestler on walls, sidewalks, lampposts and countless other places around Manhattan, something clicked for him. As Dave saw it, this sticker was transforming the public space it adorned in a way that made passersby question their relationship with the space itself. It was art in its highest form: pure, uncompromising, provocative. When Dave and Holly headed back to Indianapolis, they did so with a mission.

A couple years prior, in 1999, while she had been a student at the Herron School of Art & Design, Holly, as part of a class, was forced to participate in a school project that required using the font Comic Sans, a seemingly fun-loving but over-used font. Needless to say, by the long project's end Holly had overdosed on the font. Both Holly and Dave started to keep track of the absurd places where these clown-like letterforms were used: billboards, churches, buses, corporate mailings, restaurants. Comic Sans was everywhere. At the time, the two had no public arena in which to air their grievances about the font. But, when the Combses returned from New York, the dawn of the PEEL era broke with the "ban comic sans" sticker campaign.

Much in the same way that the "Andre the Giant Has a Posse" stickers are less about the wrestler and more about people questioning a cultural milieu, the "ban comic sans" campaign likewise serves to exhort the public into paying attention to the subtle ways certain practices can become accepted, no questions asked. In short, the "ban comic sans" campaign is an effort protesting societal control. As the mock-movement evolved and attracted design and art press, so too did Dave and Holly's fame. Before long the two were in contact with artists from around the world, exchanging thoughts on sticker-art, and amassing a formidable collection of stickers along the way. As the Combses' popularity

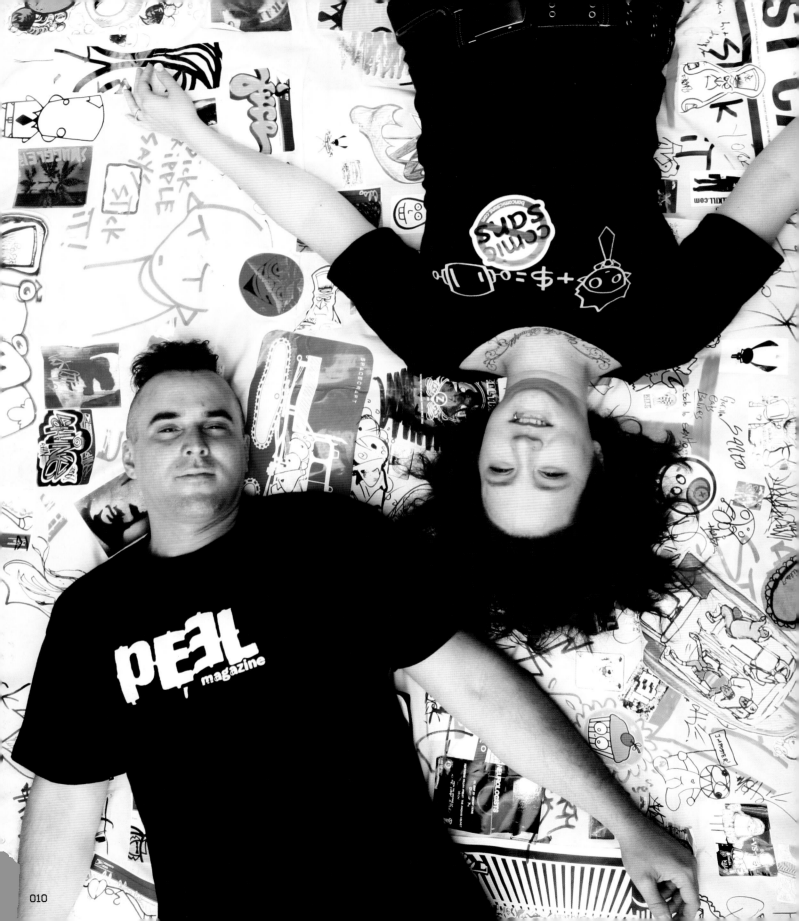

POST
NO
B

PEEL magazine

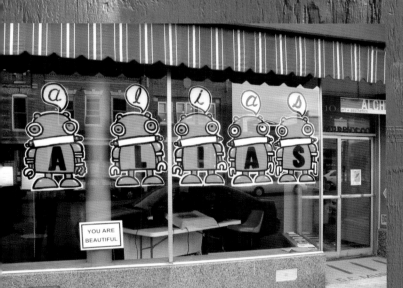

photo by Ken Sliger

11x8 full-color, glossy periodical with stickers perfect-bound inside. Sure, along the way PEEL has suffered the vagaries of independent publishing, but according to the Combses, the keys to the magazine's success have been their relationships with the artists, their, passion for the art, and their faith in God.

"Everything we've done has been a leap of faith," says Holly Combs, who has cared about the magazine with such fervor that she had been known to replace stolen stickers from a zine's bag whenever she came across one that had been pilfered. It's a personal matter. For the Combses, there is no separation between their professional lives and their private lives. Dave and Holly, accompanied by their two children Seaira and Alden, have no shortage of ideas and plans, all of which revolve around the community of artists and contributors that have informed PEEL's evolution. As the first publication dedicated to nothing but sticker-art, PEEL has not only relayed this dynamic work from all over the world, but has served as one of the critical touchstones for the community as a whole. As the Combses see it, PEEL is a family affair, and it is one large and talented family.

The duo has traded in their home office for a gallery space with the hopes of exhibiting PEEL-style work often, meeting great public enthusiasm. The couple looks to expand the magazine into any and all realms of high-quality street art, evolving PEEL from a primarily sticker-based release to one dedicated to the concord of the street-art community as a whole. According to Dave, "We will always have the streets as the roots of the magazine."

continued to grow within the sticker-art subculture, their sticker collection amassed with a persistence that they could not ignore, and the couple's love for this niche of street art grew to such a height that the only way to satiate their enthusiasm for the work and its creators was to compile the stickers in a magazine and share them with the world. In December of 2003, PEEL Magazine was born.

In less than 4 years, Dave and Holly Combs have grown PEEL's production from 200 copies distributed locally to 20,000 copies distributed internationally, from a black-and-white 8x5 inch zine bagged with stickers, to an

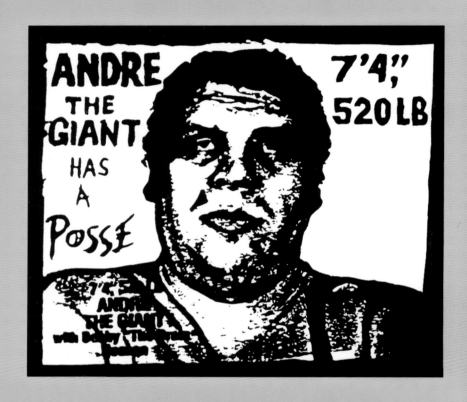

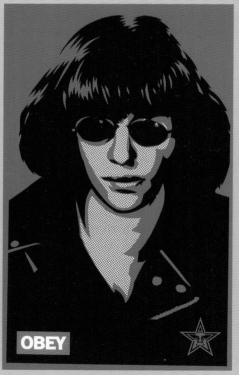

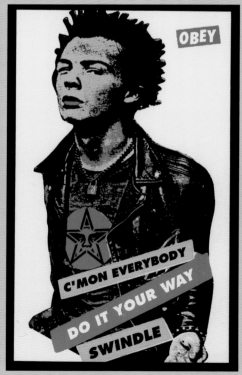

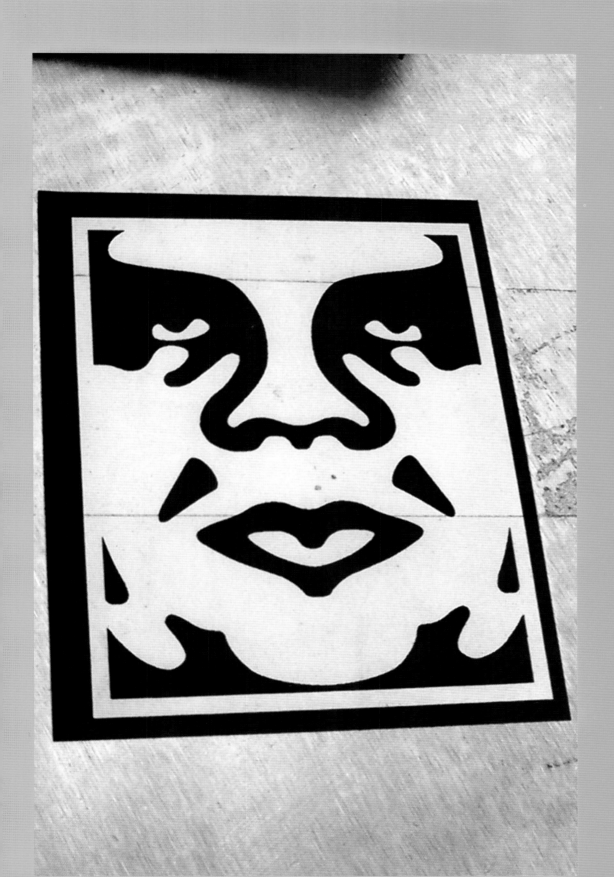

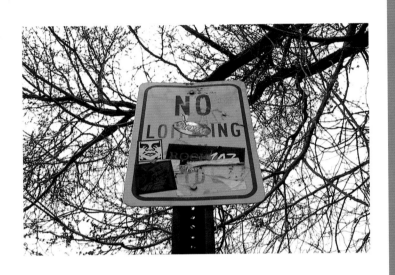

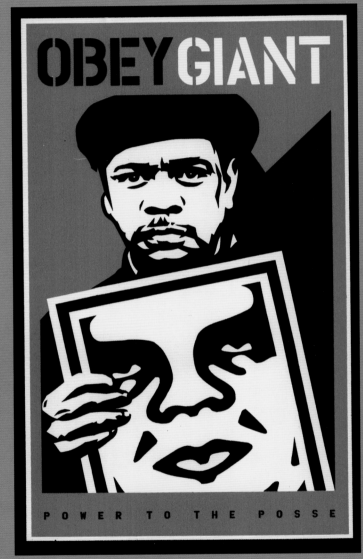

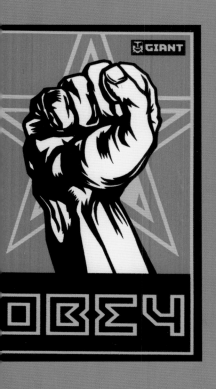

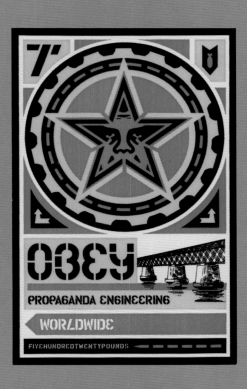

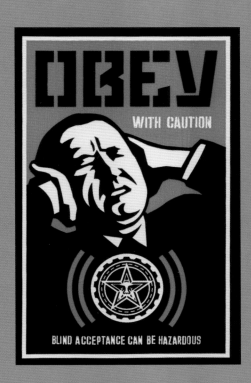

EVOKER

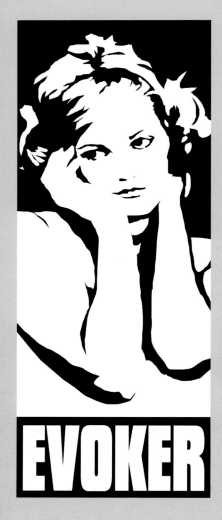

EVOKER

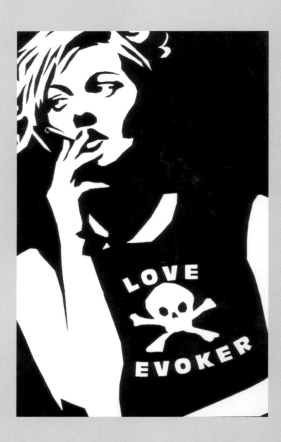

LOVE EVOKE

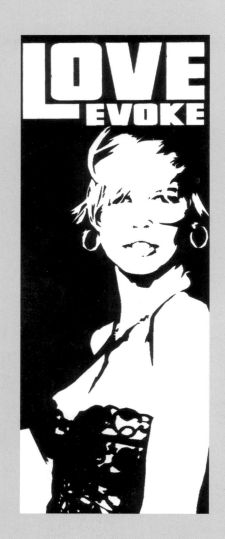

LOVE EVOKER

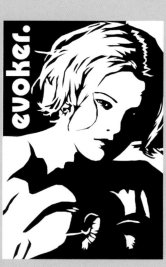

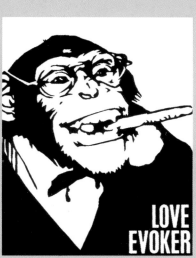

LOVE EVOKER

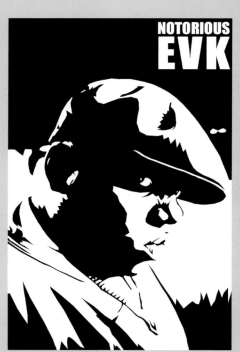

NOTORIOUS EVK

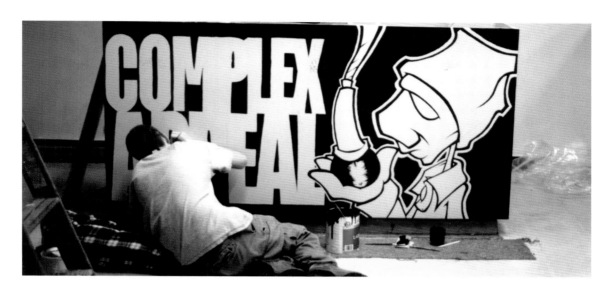

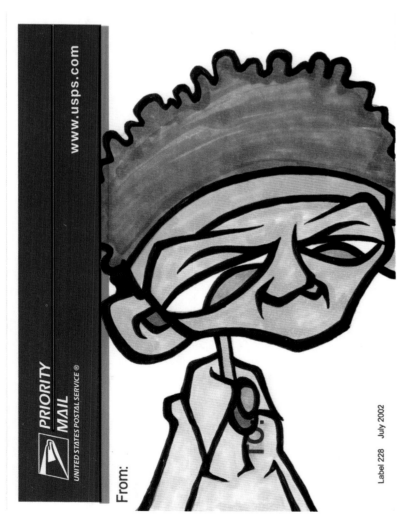

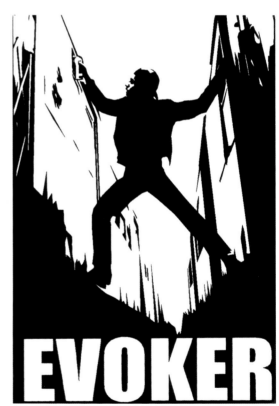

www.usps.com

PRIORITY
MAIL
UNITED STATES POSTAL SERVICE ®

From:

Label 228 July 2002

EVOKER

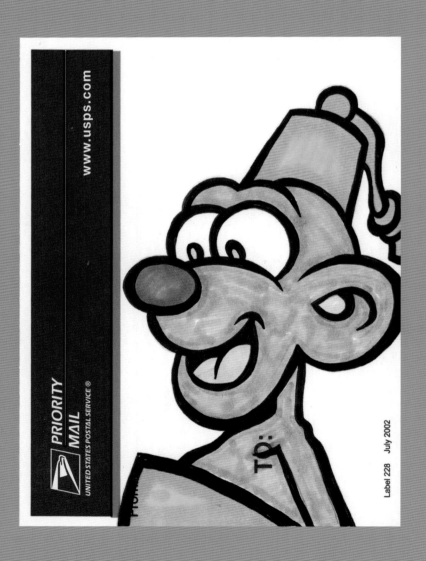

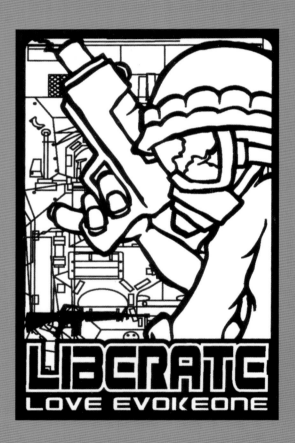

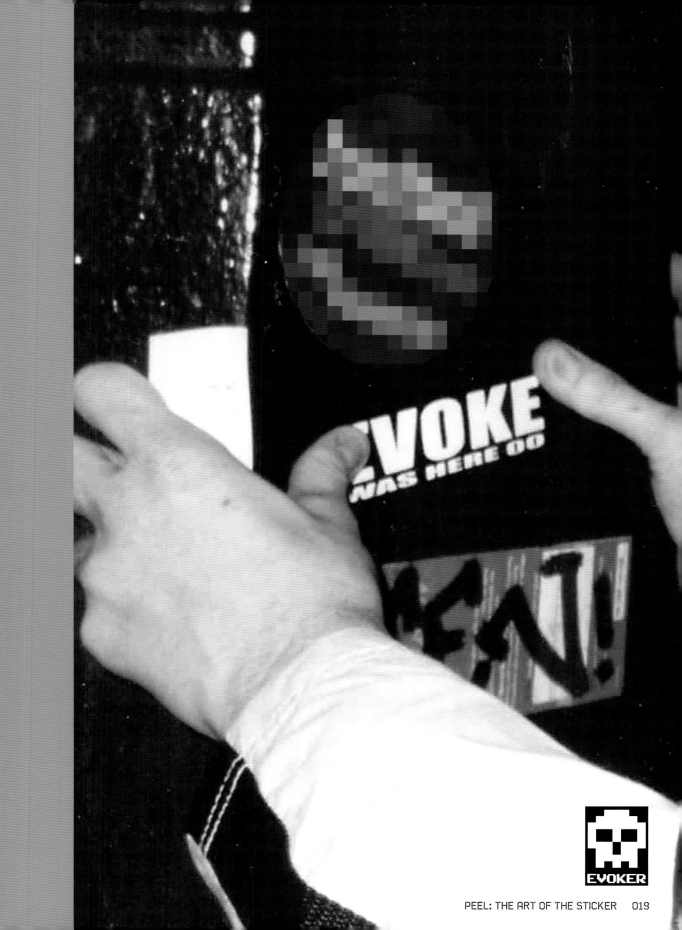

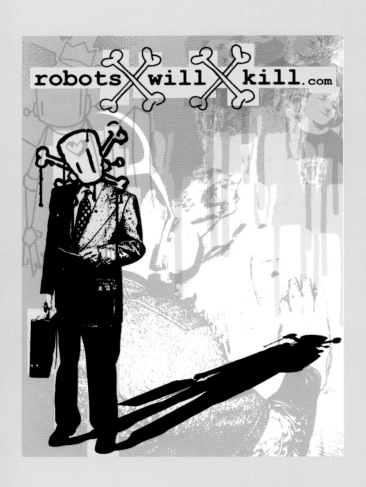

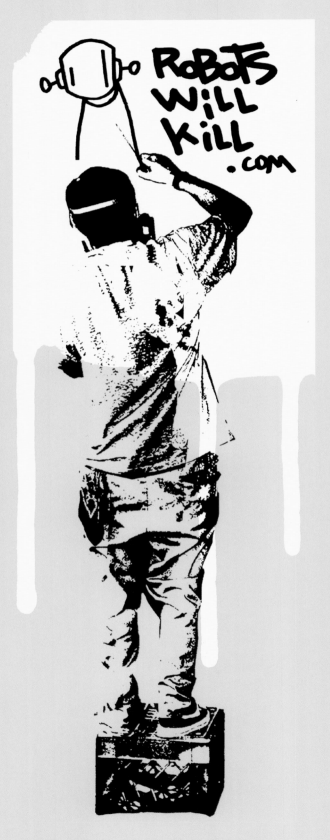

left page: Give Em Hell by James Wolanin (Issue 2)
right page: (top) Evil Bush by Zoltron (Issue 4)
(bottom) CHECK YOUR SELF by Holly Combs (Issue 6)

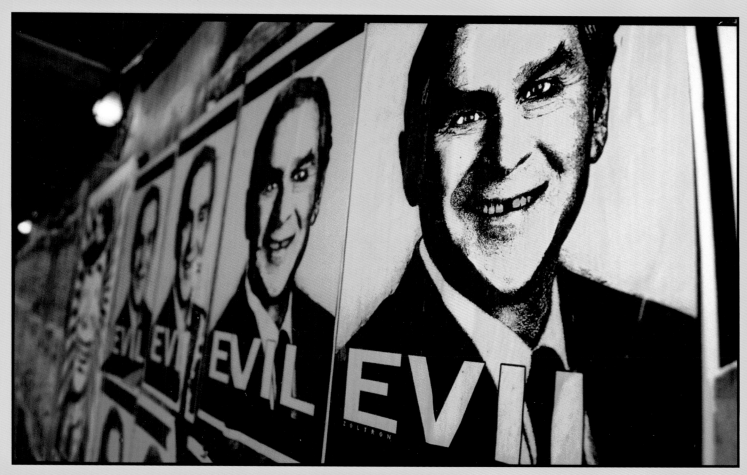

left page: (top) Implied Regurgitation (I Threw Up) Project by Michael Pilmer (Issue 1)
(bottom) The Plug (Issue 7)
right page: (left) Withremote by Nate Nolting (Issue 1)
(right) Mathew Curran (Issue 2)

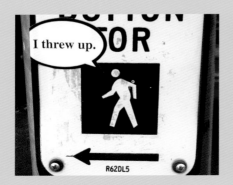

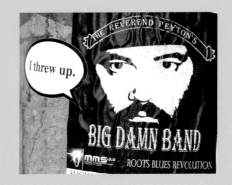

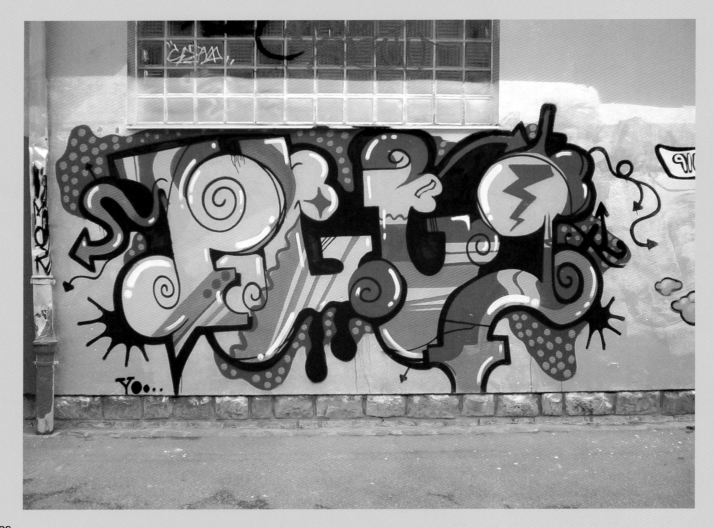

left page: (top) Mike Clark (issue 4)
(bottom) Eyeformation (issue 2)
right page: (top) Benny Gold of Stay Gold Creative (issue 3)
(bottom) Eyeformation (issue 2)

BAN COMIC SANS

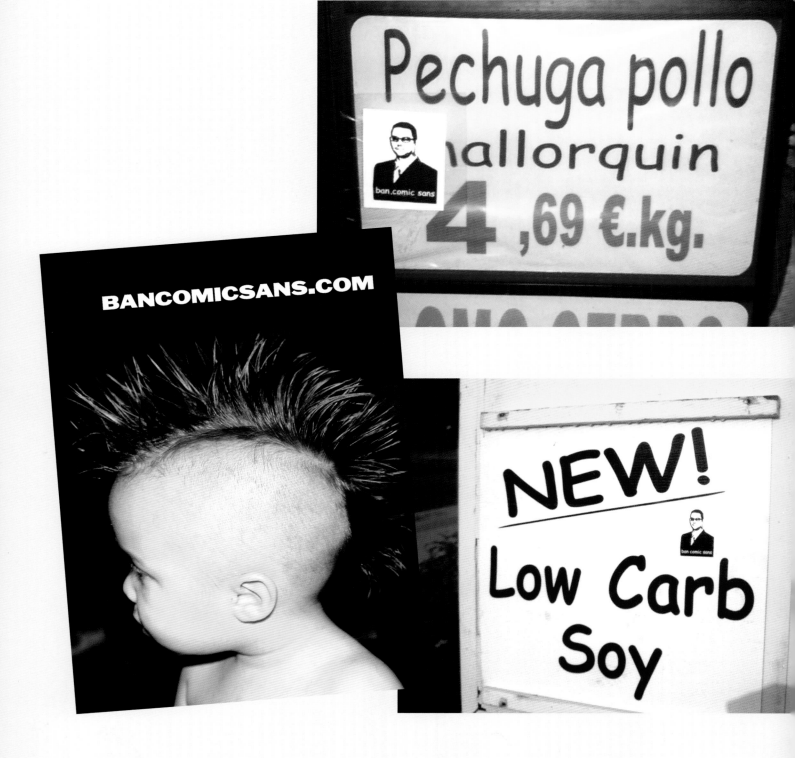

left page: (clockwise) Mural by MCA at 11 Spring Street, MCA Evil Design (Issue 8),
Nincompoop (Issue 5), Meggie (Issue 8)
right page: Eugene of Eugene and Louise (Issue 5)

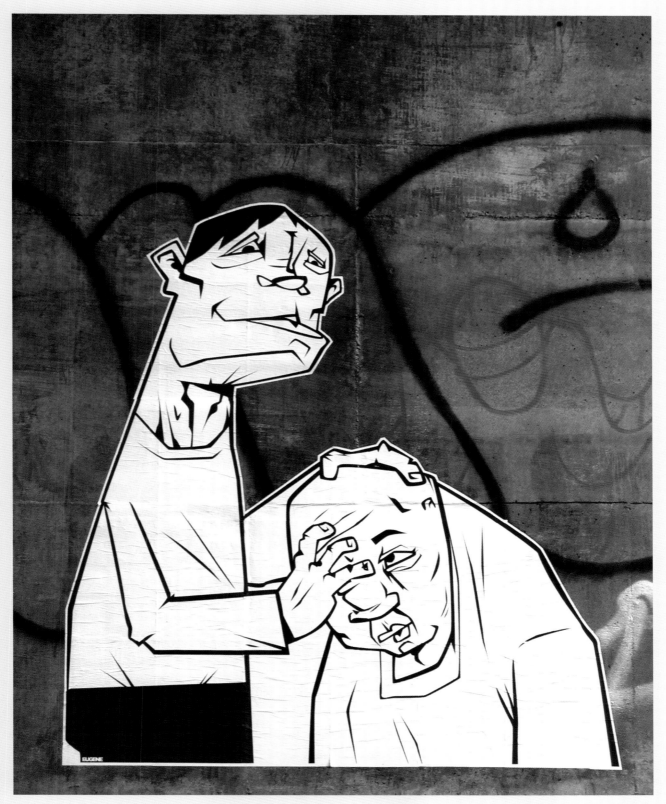

left page: Poppa (Issue 3)
right page: (clockwise) Skumskullz Project (Issue 3), Nose (Issue 7), Visual Submission (Issue 2), Foob (Issue 3), Arrrgh! (Issue 2), White Dog Bobby (Issue 7)

YOU ARE

BEAUTIFUL

you are
beautiful

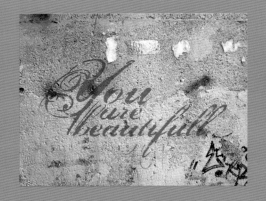

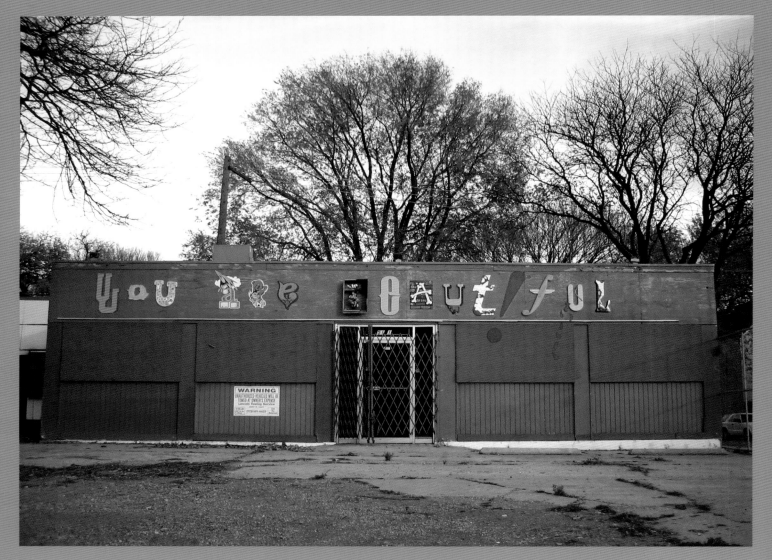

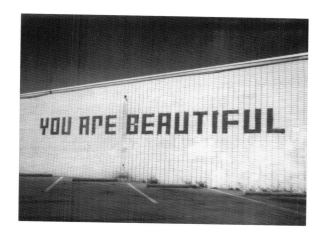

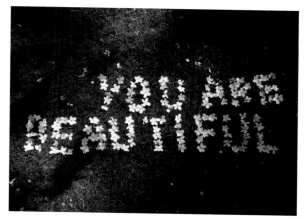

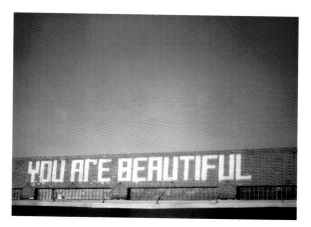

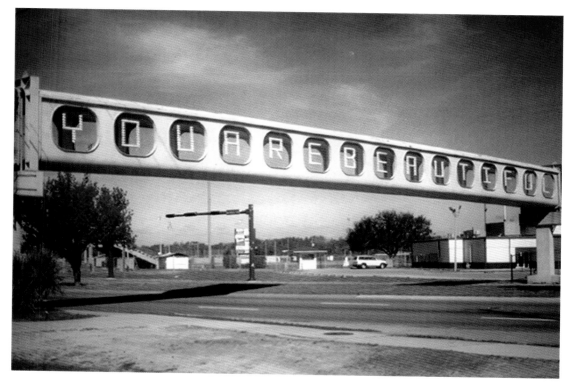

you are
beautiful

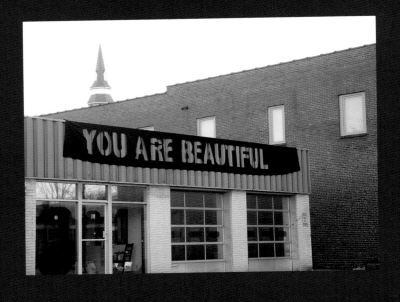

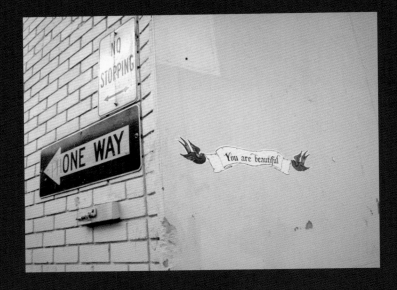

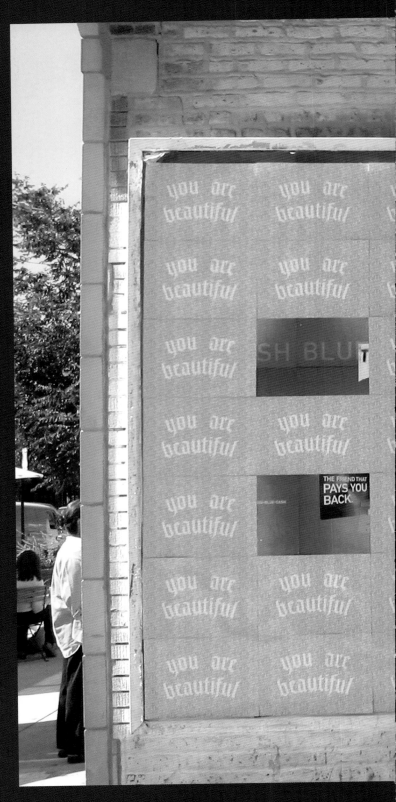

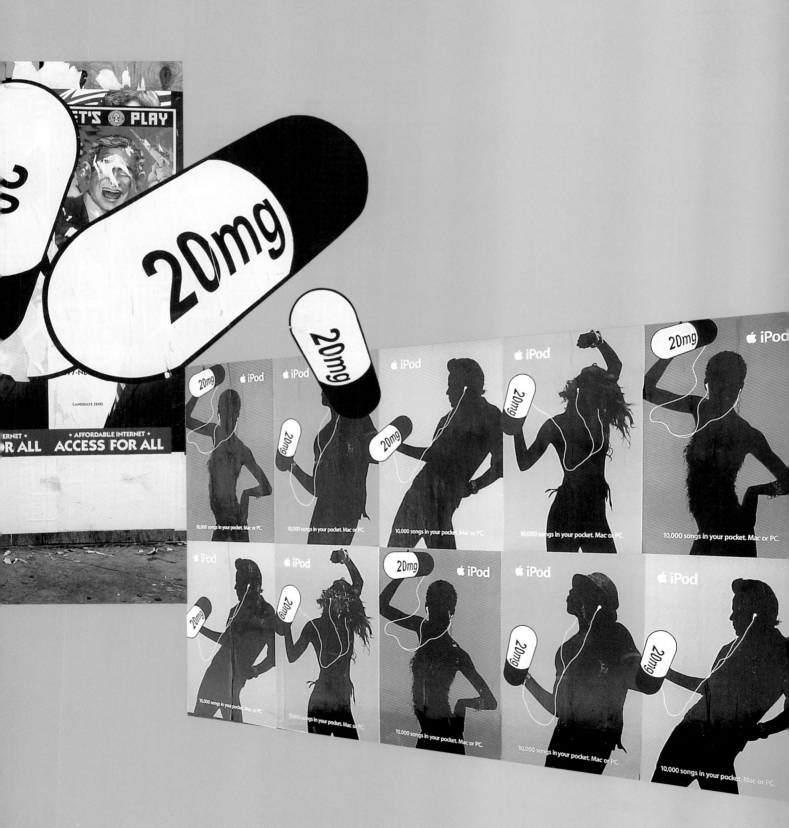

KLUTCH: PROFILE OF A VINYL KILLER.

Is your art influenced by any certain music?
Definitely. Ever since elementary school I have always been and continue to be hugely influenced by music. My stereo gets turned on with my morning coffee and goes off with the lights at bedtime.

Which band(s)/artist(s)?
A list of the bands/artists I am into would fill your whole zine. These days Coldcut's Solid Steel radio shows get the most play around my house. I have about 50 of them and am always adding to the collection. The genre mashing reminds of radio when I was a kid in the 70's and you could hear Alice Cooper followed by Curtis Mayfield.

What inspires you in your work?
Street artists everywhere. Initially it was being exposed to abstract graffiti in the mid 80's, then it was SF during the 90's which again changed my view of graffiti. Now with places like Wooster Collective showcasing what is happening worldwide I find something amazing almost everyday.

How long have you been stenciling?
I did some band names on jackets and other stuff on skate ditches around 1984-85 but only a few times. Years later I would see a few around SF, and was aware of Seth Tobocman and WW3, but overall I didn't really pay much attention to stencils. I was into a different phase of my life back then but at the same I was super into everything else happening in the Bay Area graffiti and street art wise.

Finally in 2001 while ski bumming in BC, Canada I hooked up with Ape7 from Sydney, Australia. He showed me some of his stencil work and inspired me to pick it back up. When I returned to Portland that spring I read Banksy's tutorial, made one, became super stoked on stenciling, and haven't stopped since.

What do you do when you're not making art?
Backcountry snowboarding is pretty much my number one passion and doing art is secondary. But since winter is only a few short months I do a lot more spraying than riding.

Other interests include traveling with my wife. I am also a book junkie with a particular weakness for art and old skating books. Sometimes I work but I really try to keep my needs simple so that it is kept to a minimum.

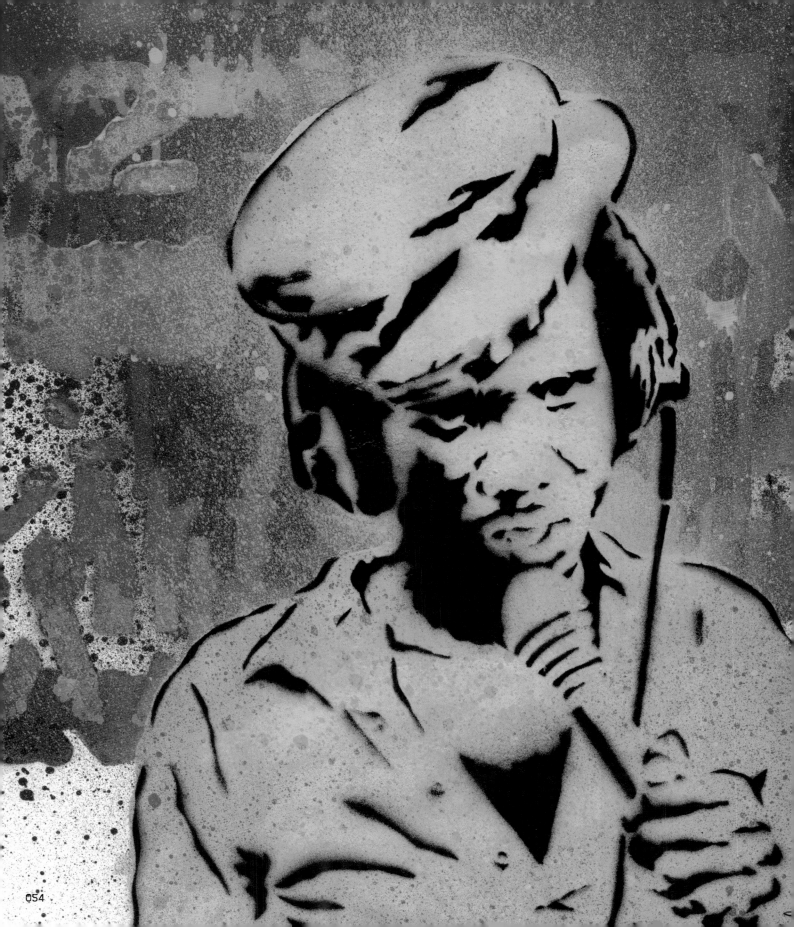

Why do you stencil on records?

Originally I was doing a painting of a turntable and had traced around a record with an oil stick. While waiting for the oil stick to dry I painted the record just to pass the time and was stoked on the result. I have always been into painting found items and was doing a lot of broken skate decks so records just seemed to be a natural progression. As soon as I did that first one it was obvious that they were a great medium. Old records are free or really cheap, work equally well on the street or in a gallery, are easy to store and ship, and they just look really cool hanging on the wall.

What have you been doing to promote the medium of stencils on vinyl?

So far I have put together two group shows of vinyl paintings from around the world which have been huge hits. After participating in the Negative Spaces show in SF, and inspired by all the cool shows happening in Australia, I put the first Vinyl Killers show together because I wanted something cool to do in Portland.

Almost immediately it totally blew up to over 60 artists and it was pretty crazy to take on that many people for the first show I ever put together. But it all went great and almost immediately people were wanting a follow up.

This year we expanded a bit to 4 days, over 100 artists, 2 venues, painting a van, a picnic, and a fundraiser for a kid's teaching garden. Several of the artists from both coasts traveled in for the shows and all the hard work paid off with a great time for all involved.

I have also been pushing to schoolchildren and have helped two art teachers introduce vinyl to their students. One cool aspect of this is that most of the kids had never seen a record before and may never have otherwise.

What would you change about the stencil art movement?

Squash the ego inflation and competition.

What's good about it in your opinion?

Stenciling is pretty easy to do and just about anyone who wants to can quickly become pretty good.

What are your future plans for...Vinyl Killers?

The whole vibe of the Vinyl Killers shows has been about showcasing vinyl painting as a medium and a community. That is the spirit that I want to keep alive and still find ways to take it to more people and to other cities. Several people have approached me about wanting to join together and we are talking about ways to make it all happen.

The other thing that I am trying to put together is to have the VK site become a PHP upload site. Then everyone around the world can add their vinyl work and we can build a document of the whole VK movement. It might help to spark things even further by providing a showcase for others without having to wait for and be selected for any future VK shows. It looks promising that we can have it added soon, hopefully early 2005.

Other shows?

For the winter I plan to retreat to the mountains for a break and then come back swinging in the spring. Painting in the rain and cold sucks so bad and riding powder is so much fun that it isn't a very difficult choice to make. I already have a couple of cool things lined up for early spring to work towards and have no intent of slowing down.

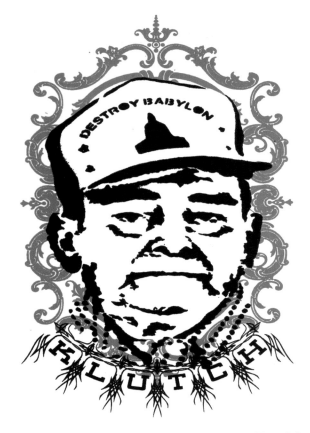

"Squash the ego inflation and competition."

Your own work?

To hook up a real workspace. Making things in the backyard is pretty limited especially when it rains which in Portland is most of the time.

Do you have any tips or tricks you'd be nice enough to share with aspiring artists just getting started?

Handle your biz and don't kill no kids.

And, go to www.woostercollective.com, do a search for Magmo The Destroyer's 5 Tips, and read it everyday. Definitely the best advice you will ever get about art, street or otherwise.

Pz

www.klutch.org / www.vinylkillers.com

me ♥
me ♥
me ♥
me ♥
me ♥
me ♥
me ♥
me ♥
me ♥
me ♥
me ♥
me ♥
me ♥
me ♥
me ♥
me ♥
me ♥
me ♥
me ♥
me ♥
me ♥
me ♥
me ♥

Tue, 23 Nov 2004 21:32:30 -0800 (PST)

Betreff: PEELzine

hello syl,

here are your questions. hope all is well.

let me know that the pkg. got there

in one piece. luv luv,
holly

me ♥ **Questions?**

What inspired you to begin stickering? What year did you start?

I'VE BEEN CREATING CHARACTERS + STORIES (...) AS LONG AS I CAN THINK. WHEN "STREETART" (STICKERS, STENCILS, PASTE UPS ...) INCREASED MASSIVLY AFTER YEAR 2000 MY CHARACTERS KEPT BEGGING ME TO PUT THEM UP ON THE STREET ... FIRST I WAS A LITTLE SCARED BUT THEN I DID IT AND IT FEELS GREAT!

STREET CAT

Why do your characters like to live on the street and not in a gallery?

WELL, THEY MEET A LOT MORE PEOPLE ON THE STREET. PEOPLE OF EVERY AGE, BABIES, INFANTS, CHILDREN, TEENS, TWENS, ..., OLD PEOPLE, WHO DON'T HAVE TO PAY TO BE ABLE TO MEET MY CHARACTERS. NOT JUST THE SELECTED AUDIENCE WHO COMES TO A GALLERY OR MUSEUM. THAT'S VERY INTERESTING. ALSO THERE CAN BE DIRECT REACTIONS: PEOPLE CAN CHANGE / ADD TO STREETART.
BESIDES, MAYBE SOME OF MY CHARACTERS WOULD LOVE TO LIVE IN A GALLERY ... IT'S JUST THAT NO ONE HAS INVITED THEM SO FAR ☺

YEAH. EXACTLY.

I'M THE OUTDOORS - TYPE

From a female point of view, how does it feel to participate in such a male-dominated scene?

IN GENERAL IT'S NOT REALLY IMPORTANT TO ME IF ANOTHER ARTIST IS MALE OR FEMALE ... IT'S MORE IMPORTANT IF HER/HIS ART SPEAKS TO ME AND HOW WE GET ALONG. BUT THERE ARE A FEW WOMEN OUT THERE WHO REALLY INSPIRE ME, LIKE E.G. MICROBO OR MISS VAN (...).
I'D BE REALLY HAPPY + EXCITED TO GET TO KNOW THEM AND TALK ABOUT THE FEMALE POINT OF VIEW ON STREET ART!

(Deutschland + Welt

...ND/ALLEMAGNE

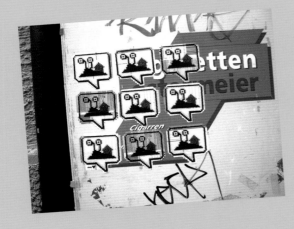

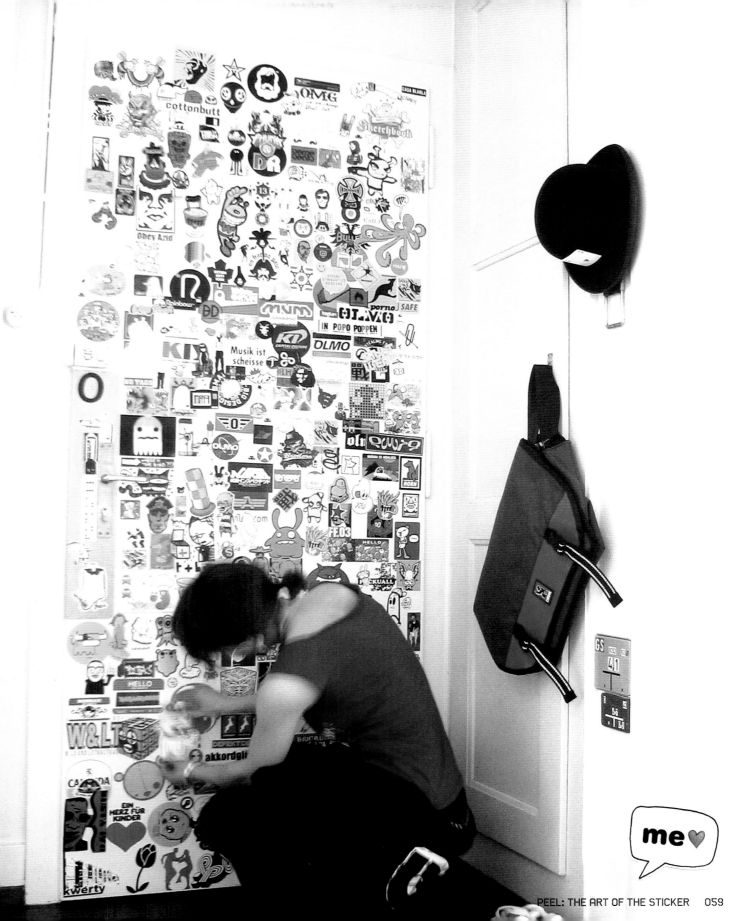

me♥

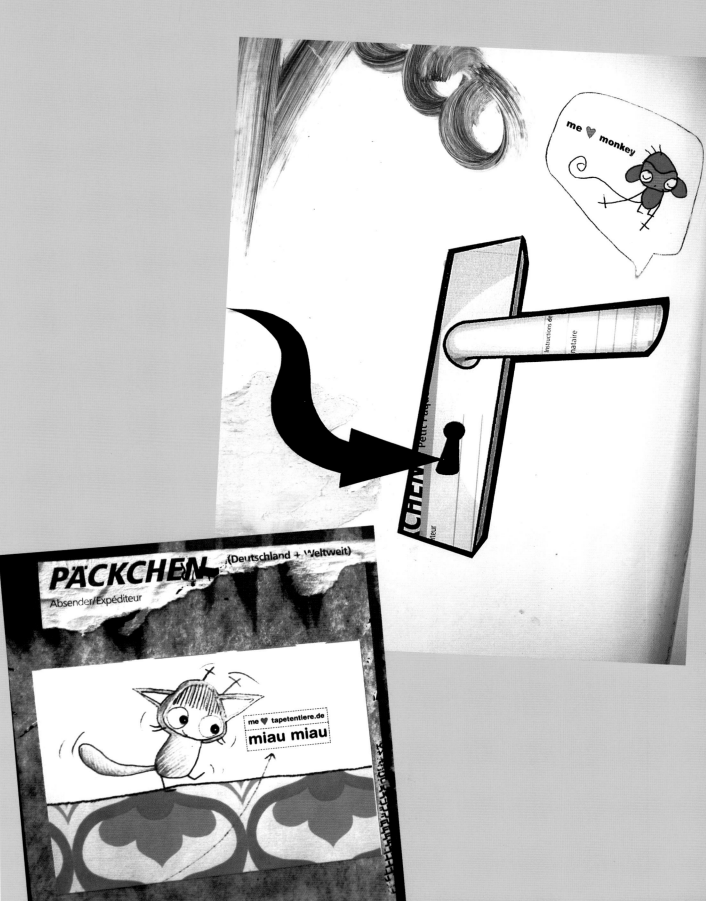

he ...llo

gänsefüsschen

What is the street scene like in _____? your city

MUNICH OFFERS QUITE A LOT OF VARIETY IN STREETART (STICKERS, STENCILS, POSTERS, PASTE UPS, GRAFFITI ...) ALTHOUGH IT'S A SEVERELY CONTROLLED CITY.
STILL SOMETIMES I WISH I WAS IN A MORE INSPIRING PLACE (LIKE BERLIN, BARCELONA, TOKYO...)

It has been a dream of yours to have your own book.

That dream has recently come true. What would you like to say about that experience?

ALTHOUGH IT'S BEEN SOSO HARD TO REALIZE THIS PROJECT (NO TIME NO MONEY NO REAL ACKNOWLEDGEMENT NO HELP ...) AND I WAS VERY CLOSE TO GIVING UP SEVERAL TIMES AND IT'S STILL INSECURE IF I MANAGE TO SELL IT ➡ I'D DEFINITELY DO IT AGAIN! JUST CAN'T HELP IT. NEXT PROJECT IS ALREADY ON MY MIND...

me ♥

How does your day job influence your personal creativity?

AT MY CURRENT DAY JOB I DEVELOP DESIGN CONCEPTS MOSTLY FOR THE AUTOMOTIVE INDUSTRY. IT IS VERY ABSTRACT AND HAS MORE TO DO WITH MARKETING + STRATEGIES THAN WITH REAL DESIGN. ACTUALLY I FEEL LIKE MY DAY JOB RESTRAINS ME FROM BEING CREATIVE IN GENERAL. IT'S ALL ABOUT THE MONEY...

If while eating your breakfast cereal a green fish jumped out of the box and asked you

"what three wishes may i grant you?" what would be your response?

➡ MYRIAD MORE WISHES !!!
IF THAT DOESN'T WORK

WOW, GREEN FISH! COOL.

1) A BETTER WORLD FOR EVERYONE: PLANTS, ANIMALS + HUMANS.
2) TO BE ABLE TO MAKE MY LIVING WITH WHAT I ENJOY DOING: DRAWING, WRITING, DECORATING, COOKING, TRAVELLING....
3) LAST BUT NO LEAST: A DOG.

me ♥

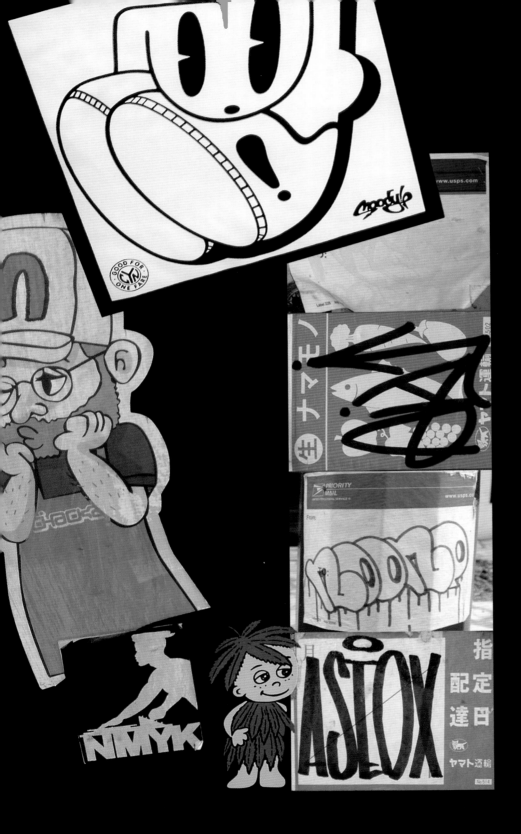

TOKYO'S POSTMODERN STICKER CULTURE

by Scot Orser

There are many ways to experience and enjoy art wherever you go. One way is to visit an art gallery where you receive the art in a manner controlled by the artist. The art is on the wall, protected from hands, and carries a price tag. On the opposite side of the spectrum, street art is a very hands on medium in which participation is free for all. One can spray over, rip down, or cover up whatever is within arm's reach. Gallery art stays indoors protected with glass and controlled lighting whereas street art fades and changes over time. These differences are analogous to the differences in modernism and post-modern-ism, where the former is made to last, and the latter is made to change. In most urban centers there is a sticker art culture. But what separates Tokyo is that the entire city is always in flux reflecting a broad mindset that is post-modern at its core. These ideas flow vigorously into a vibrant tag and sticker culture that is strange and colorful, and is brimming with excitement.

To the casual observer the wall may just be covered with junk, or noise, but a closer examination reveals emerging themes and microcosms. Artist's signatures continually evolve bouncing new ideas off one another without any face-to-face contact. These taggers copy or anti-copy to differentiate themselves among their peers. Hello stickers and shipping labels come in all forms from pre-printed vinyl to hand written with a marker. These artists alter their style, constantly drawing from images of their childhood to current television shows. All these factors boil down to one common element: identity. The more stickers up, the more established the identity becomes leading to a broader appeal and respect within the sticker community.

This respect eventually reaches a level of wide notoriety on the brink of pop culture. These artists usually find a motif that works and stick with it keeping its core true to form. Their designs often achieve worldwide recognition by many sticker enthusiasts. These designs become personalities unto themselves and only copy from within creating a feedback loop that results in recognition from only one symbol.

The road to artistic success has never been so direct as it is with today's sticker culture. The street art scene has become influential enough to trickle its way into media and also come full circle back into the art galleries. Using public space as canvas has forced the masses to look at street art willingly or unwillingly. The results are an unconscious awareness of its presence. This awareness is what perpetuates this medium in our post-modern society.

comments or questions are welcome.
pushtaktix@gmail.com

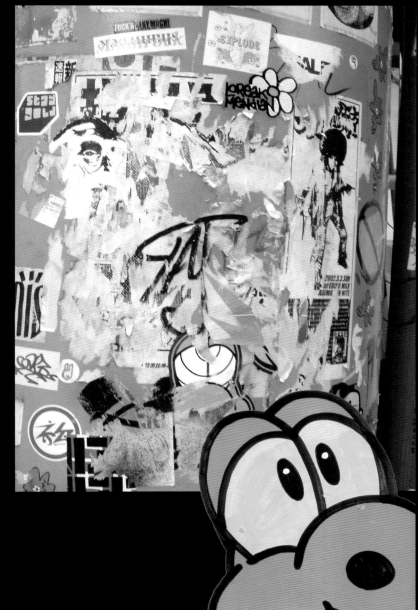

Gallery art stays indoors protected with
glass and controlled lighting whereas
street art fades and changes over time.
These differences are analogous to the
differences in modernism and post-modernism.

left page: (clockwise) Mathew Curran (Issue 2), Tika TGS (Issue 6), Mural in Lisbon (Issue 8), Waleska (Issue 7)
right page: (clockwise) Blackbooks Stencils (Issue 6), Ace (Issue 6), ©opy®ight (Issue 8), Ace (Issue 6), Various Artists at Pictoplasma, Berlin (Issue 8), Various Artists at Pictoplasma, Berlin (Issue 8)

STENCIL, SPRAY AND

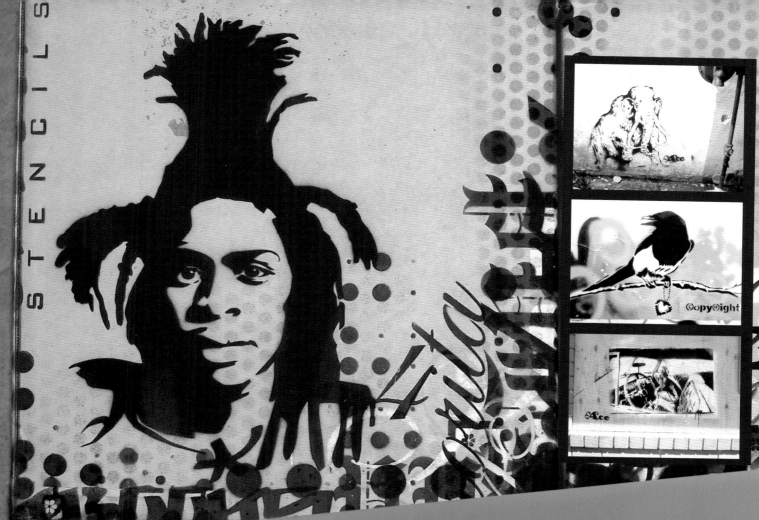

STENCILS

DRAWINGS

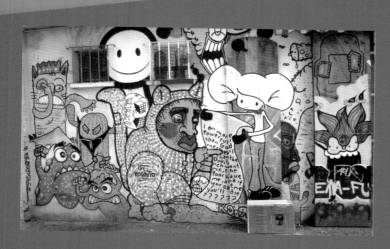

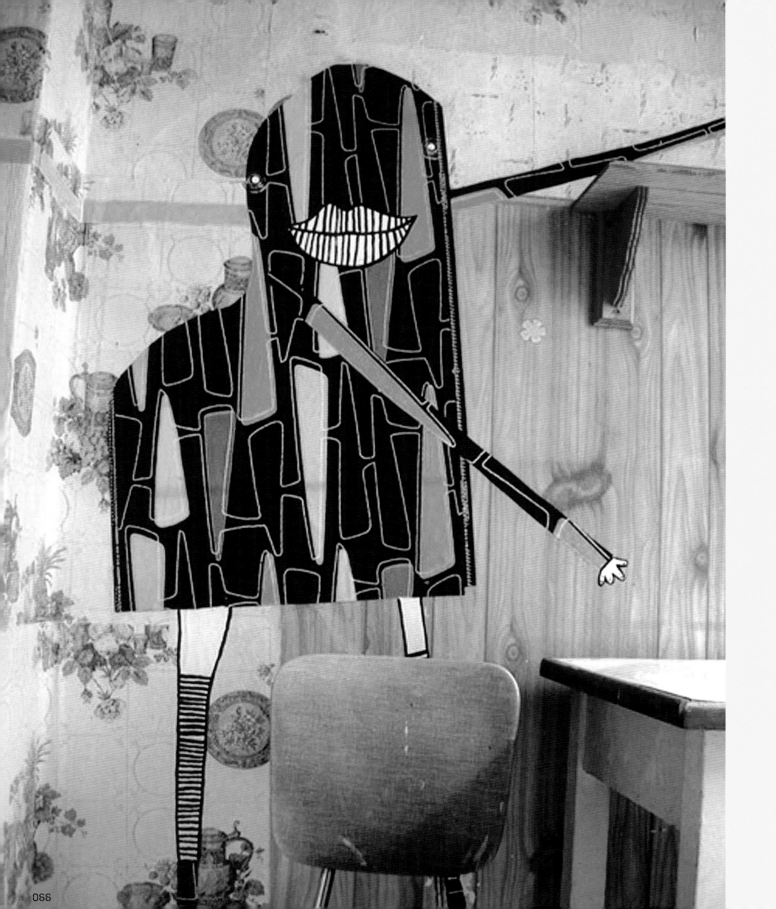

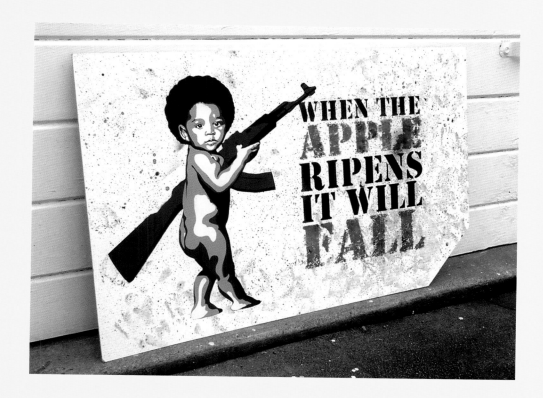

left page: (Mymonsters (Issue 8)
right page: (top) Brownsugaaa (Issue 6)
(bottom right) Apish Angel (Issue 3)
(bottom left) Apish Angel (Issue 3)

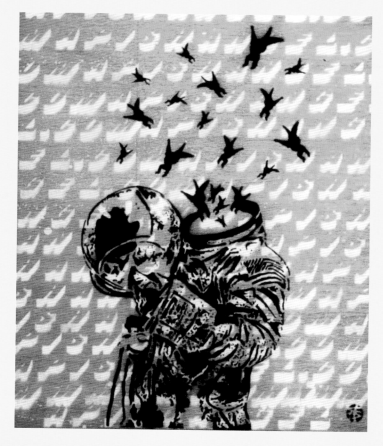

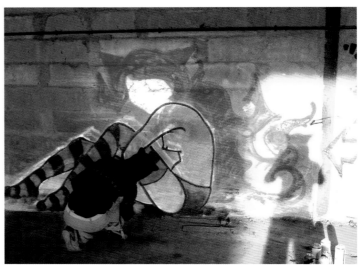

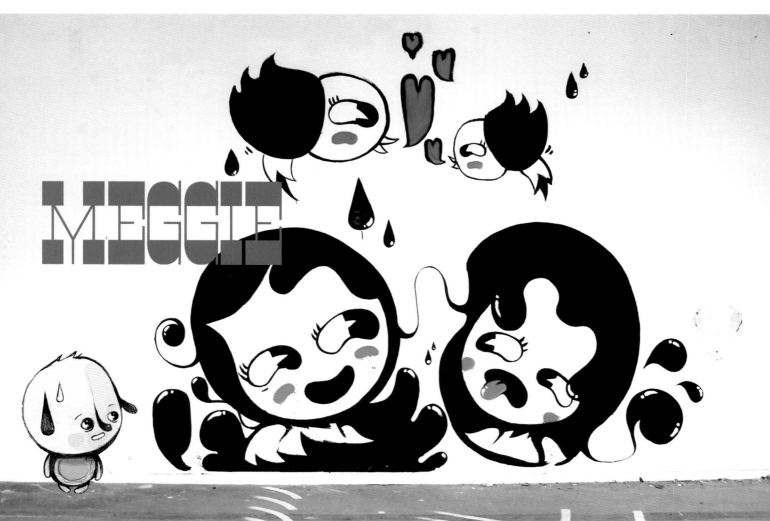

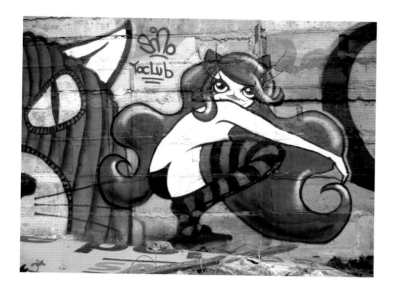

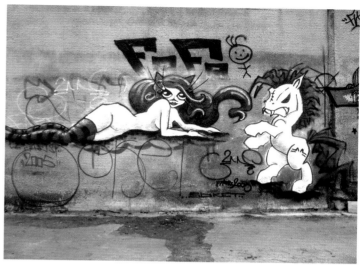

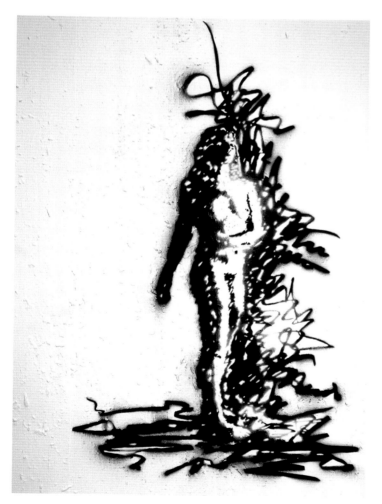

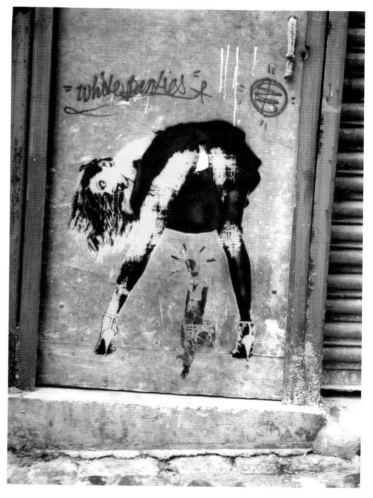

left page: (clockwise) Rooty Cutie (Issue 6), soket of eviltoys (Issue 6), Meggie (Issue 8)
right page: (clockwise) soket of eviltoys (Issue 6), soket (left) and lyl (right) of eviltoys (Issue 6),
Apish Angel (Issue 3), Mathew Curran (Issue 2)

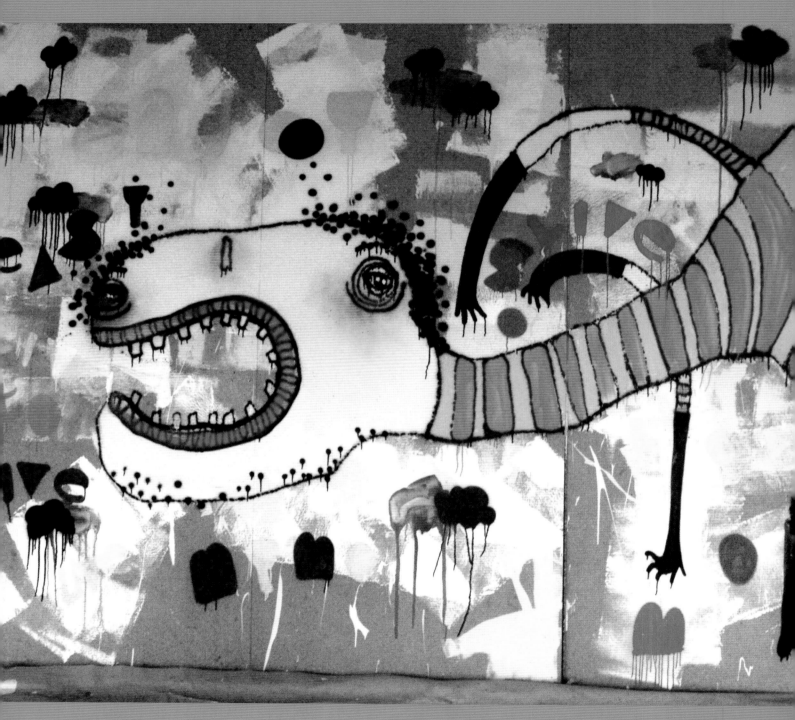

Mymonsters (Issue 8)

BORT (3rd place winner)

Slackart (1st place winner)

Kaneda (2nd place winner)

THE POWER OF PINK
A TALE OF BUFF MONSTER PROPORTIONS

When did the Buff Monster begin appearing?
The character first appeared on the streets of LA the first month of 2001. Flattened spray paint cans, with drawings on them.

How did you get the idea to paint on crushed cans?
One of the biggest ironies of graffiti is that writers use the most permanent inks and paint to create work that is anything but permanent. Posters, and most other things aren't permanent either. Metal was made to last.

Is Buff Monster an alter ego, like Superman and Clark Kent?
No, its all me all the time.

Is "Buff" a description of the Monster's voluminous musculature, a reference to nudity, or is it an allusion to graffiti removal / abatement efforts?
Its all of those, of course, but my inspiration is the context of graffiti removal. I painted graffiti for years and it was my life. Attending one of the top ten high schools in the nation and painting graffiti was all I cared about.

We didn't drink, do drugs, mess with girls; all we did was draw and paint and take photos.But, of course, my experience of graffiti changed a lot once I moved to LA. Meeting graffiti writers perpetually disappointed me, the risk/reward structure was ridiculous, and the hypocrisies of graffiti just became more apparent. I hadn't seen any work being done in the name of the equally powerful and important aspect of graffiti, that is, it getting buffed.

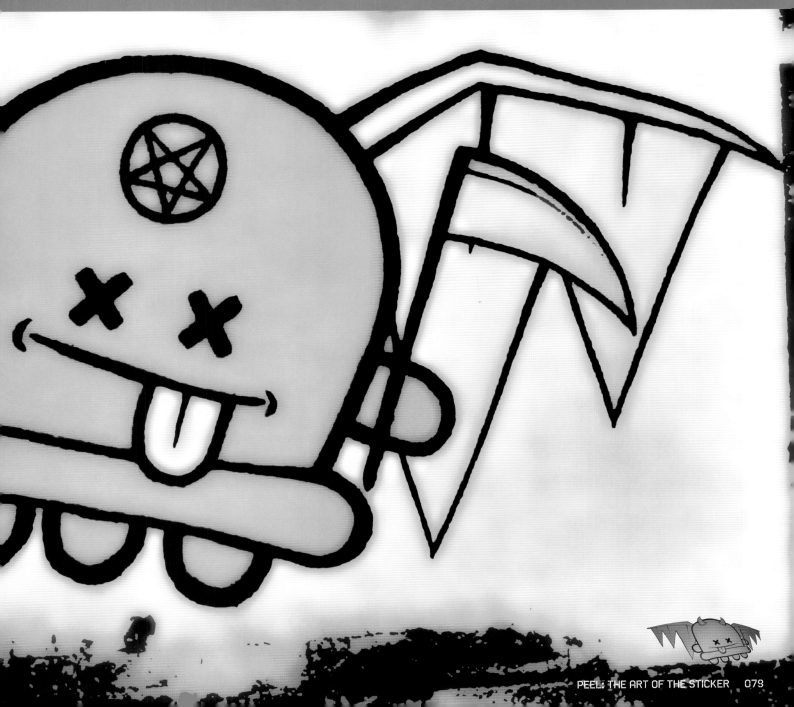

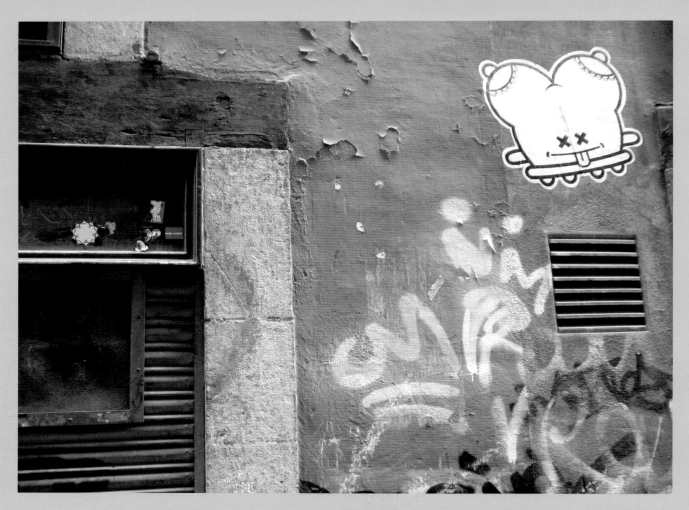

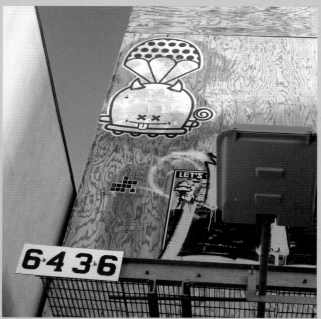

The Buff Monster recently appeared in London, Milan, and Barcelona. Would you like to say anything about those cities and the tour?
I met rad people everywhere I went. It was really inspiring. I saw a whole new way to create work and be an artist. But between getting taken down to the police station, getting a fine from the subway authority and the lack of English speaking people in Milan, I don't need to go back there for a while.

In addition to your street work, you also show in galleries. What are the pros and cons of each in your opinion?
My heart is in the street work. If I could only do one for the rest of my life, it would probably be street art. Doing gallery shows, of course, offer everything that street art lacks: a safe space to take on rad and ambitious projects, an opportunity to have a killer party, and a chance to make some money. Since I take a loss on everything that I put up in the street, if I can make a little money at a gallery, then it all evens itself out.

How do you answer the criticism that doing gallery shows is "selling out"?
That's small thinking and its not part of my world. No one has ever accused me of selling out. I can't even believe people still buy into that idea.

Tell us a little about your "Lick it Up" show, and "Pink is Power".
Lick It Up really captures my passion for sex and heavy metal. So does Pink is Power.

Can you talk a little about collaboration? This is the collaboration issue, so we have to work that in somehow. Didn't you do a collab with Paris Hilton?
Yes, we got Paris down to the gallery to do a photo shoot a few years ago. That was just before she had tons of magazine covers and established herself as a household name. That was ridiculous, to say the least, but I wouldn't really call it a collaboration. More exciting for me are the recent porn shoots that I've been involved in. Those really are collaborations; we have different skills and intentions but come together to work on something that really excites both of us.

What do you do in your day job?
I've been the Creative Director of BPM since about October of last year. Last week I just finished my seventh issue of the magazine. I had worked in magazines for years before that. I did design and production for Hot Rod, Super Street, Motorcyclist, Dirt Rider, Super Streetbikes and ATV Rider. BPM is the best magazine job I've had yet, and I wouldn't be there without my buddy Chris Hull.

Do you like electronic music? Isn't it pretty much 14-year-old boys making songs on their computers and stuff?
I'll throw in the occasional Adult or Fischerspooner CD, but its pretty

much all metal all the time. I absolutely love everything about metal. the lyrics, the style, the guitar riffs, the attitude, the drums, the groupies. Fuck yeah. I don't want to listen to anything else.

What can we expect to see in the future?
More titties, more pink, more satan, more posters, more ridiculous photo shoots.

...and more Buff Monster at www.buffmonster.com.

"My heart is in the street work. If I could only do one for the rest of my life, it would probably be street art."

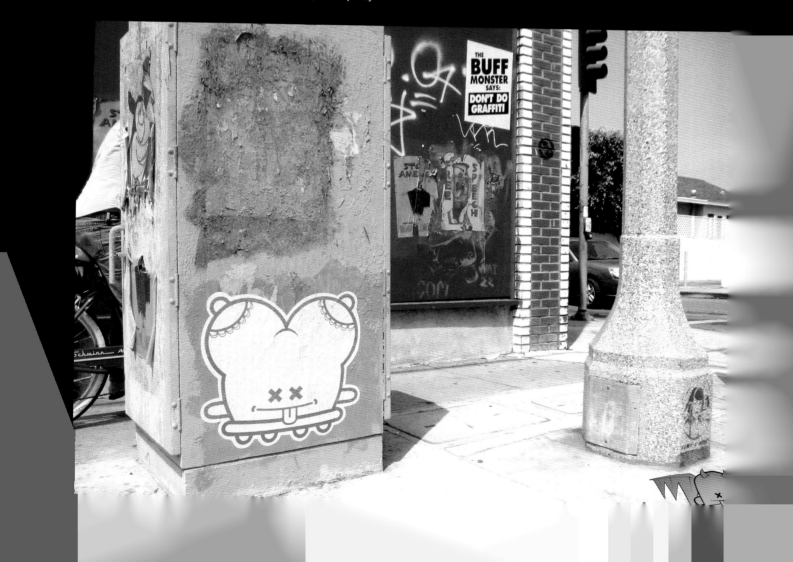

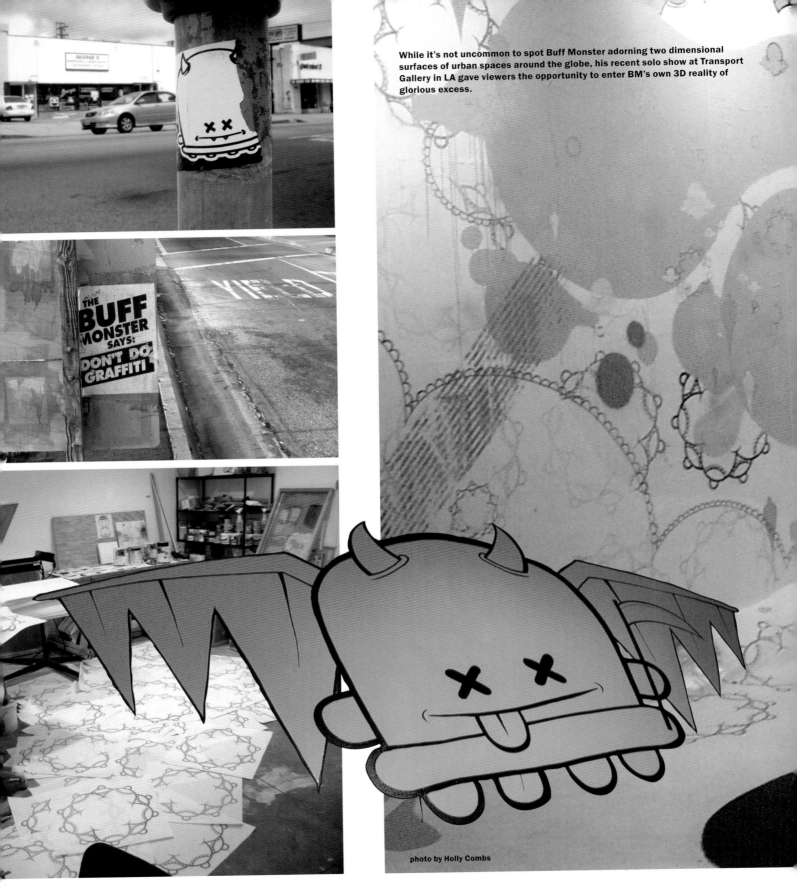

While it's not uncommon to spot Buff Monster adorning two dimensional surfaces of urban spaces around the globe, his recent solo show at Transport Gallery in LA gave viewers the opportunity to enter BM's own 3D reality of glorious excess.

THE BUFF MONSTER SAYS: DON'T DO GRAFFITI

photo by Holly Combs

082

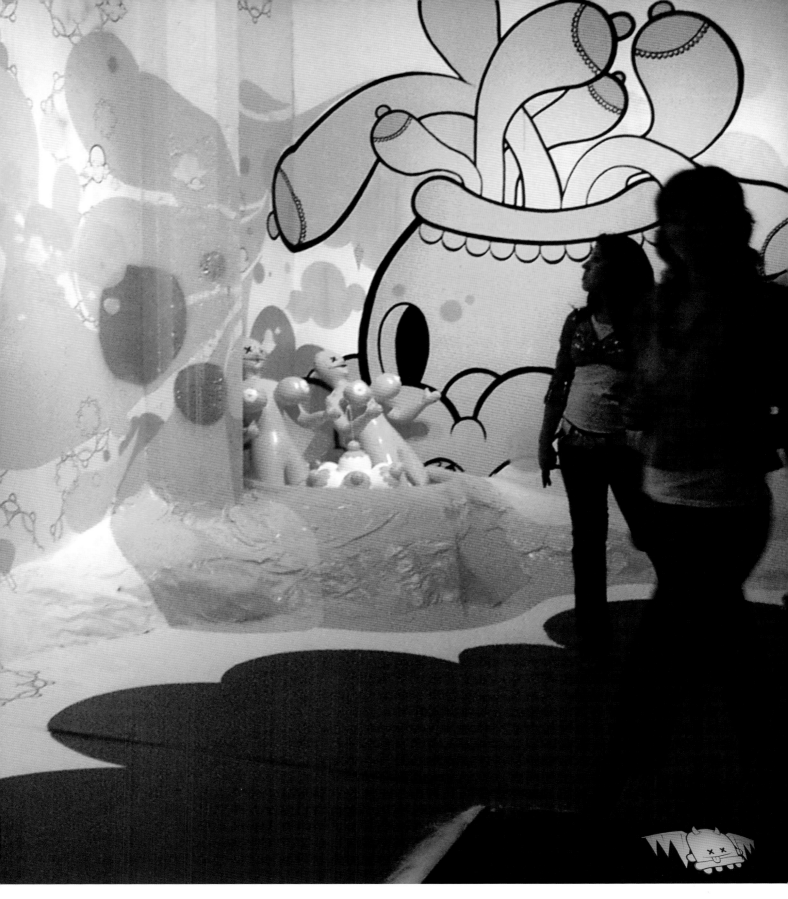

MUTI INDUSTRIES

We want to keep people aware of the fact that we are South African, and that we are unique.

Hailing from a land of glorious natural beauty and wonderous landscapes, Muti Industries gave PEEL magazine a glimpse into South Africa's thriving urban culture. Here's what we learned.

When did Muti begin?
In 2002. We were in the middle of a humid summer just north of the Transkei* coast. With plenty of time in the bush and the sea, something creative was bound to spark.

What does "Muti" mean?
"Muti" is medicine prescribed by an African traditional healer or "Sangoma". We chose the name because it holds a wealth of imagery and inspiration. If you walked into an African healer's shop in Grey Street* in the heart of Durban's* city, you would find an array of dried skins, bones, crushed herbs and jars of opaque liquids. Things which are taboo in the first world, but are very much part of African life.

How do your stickers and streetwear reflect those historical and cultural roots?
We research African cultures, finding visual imagery from the past. We blend it with street style, placing this in the contemporary landscape. It's a juxtaposition and commentary on our historical roots and rich history. We want to keep people aware of the fact that we are South African, and that we are unique. When someone wears our clothing they're representing "youth culture" in Mzansi*. People supporting the local labels are not slaves to cultural domination by the west.

Do many people confuse Muti / multi?
I guess anyone who isn't South African may confuse it. We have 11 official languages in this country, but "muti" is understood by everyone. Some people practice it, some people ignore it and some people fear it... but everyone knows about "muti".

Is Muti Industries a crew?
Muti Industries is myself and my brother, Carrick. The stickers have always been my passion.

How is the sticker and stencil scene in South Africa?
It was small to non existent a couple years ago, but now it's pretty big. It's a constantly growing scene: people get involved, then move into other stuff. Cape Town is a very creative city, so young artists wanting to express themselves all turn to the street at some point. Mostly it's just bubbling under the surface, you can sense the potential all around you.

Do you deal with much resistance from the powers that be: getting fined, buffed, etc?
It's not too hectic, I mean you've just got to be cautious. Long St* in Cape Town was peppered with sticker art at one point just about over a year ago, which was great. It had been a gradual build up, then the bureaucratic b#&tards realized and cleared all the work. It hasn't quite reached that point again, they keep things pretty tidy now. There are also police cameras spying the streets. You've just got to be sneaky, but that's part of the fun.

Do you have a day job apart from Muti Industries?
I work as a graphic designer during the day. I also freelance as a designer

What do you see as the future for Muti?
We will keep on evolving and developing progressive designs. We're living in an exiting time here at the moment. We've had 10 years of democracy and we want to continue to be a part of the cultural revolution. The stickers will keep on going up to give our urban structures some visual interest. Our clothing label is growing and picking up momentum on the local scene. We would really like to get Muti overseas. There is obviously a huge market outside of South Africa's borders, and we'd like to get our stuff out there. We're know we're offering something quite unique.

For more on Muti Industries visit:
www.muticlothing.co.za

Transkei: Rural area of the east coast. Rolling hills with pristine, undeveloped coastline
Grey St: You'll find some crazy inspirational stores here, with an Indian/African mix of cultures
Durban: A bustling African city in KwaZulu-Natal
Mzansi: Slang for South Africa
Long St: Street in the middle of Cape Town's city. Full of fashion, clubs, restaurants and cafés

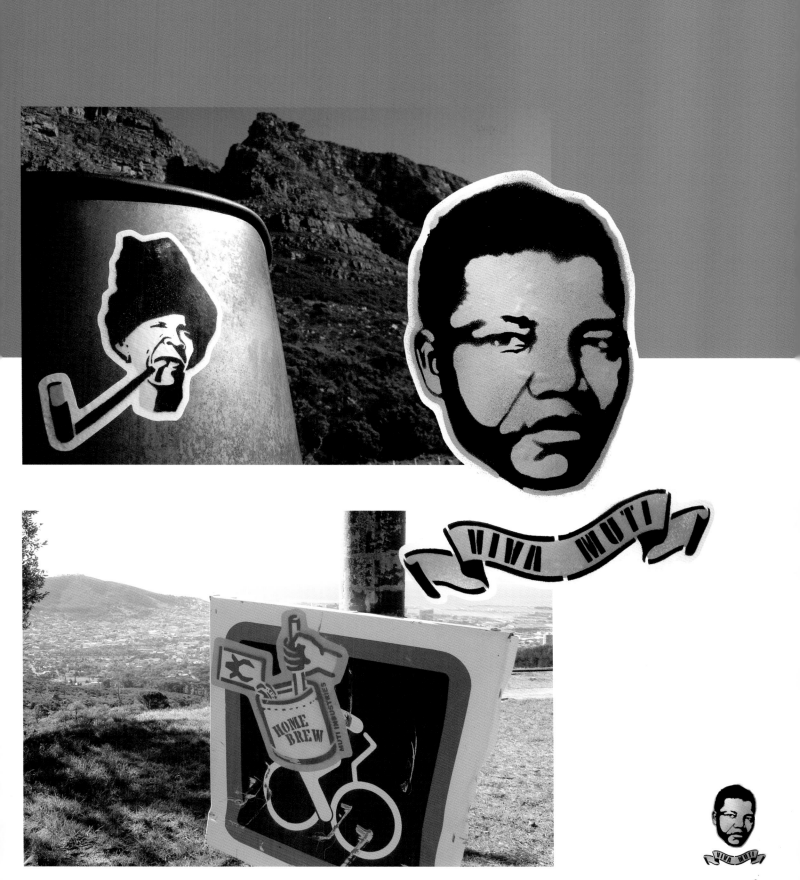

N/PLYWOOD

When did you start making stickers?
About 1 1/2 years ago.

Any idea how many wooden cigarette stickers you've made since then?
Way over 1000.

Do you smoke?
I quit about 4 years ago. I still smoke an occasional cigar.

Which is more addictive in your opinion - smoking or making wooden cigarette stickers and sticking them up?
I think making stickers can be as addictive but much easier to control. I've made art anywhere at anytime. To smoke comfortably you have to be in designated areas.

Ever wonder if seeing your stickers up on the street have made it difficult for people trying to quit smoking?
I've never wondered that, but that is a great question. If so, I'm really sorry.

Some of your stickers have recently fallen victim to the Battleship Bomber, that guy who paints over everybody's art with dull gray paint. Can you tell us a little about that and how it made you feel?
He has bombed over me before and I have removed, redone and replaced everything of mine he has tried to abolish. The battleship bomber should realize that there is no thrill in painting over what has been done. The thrill in this is getting up first.

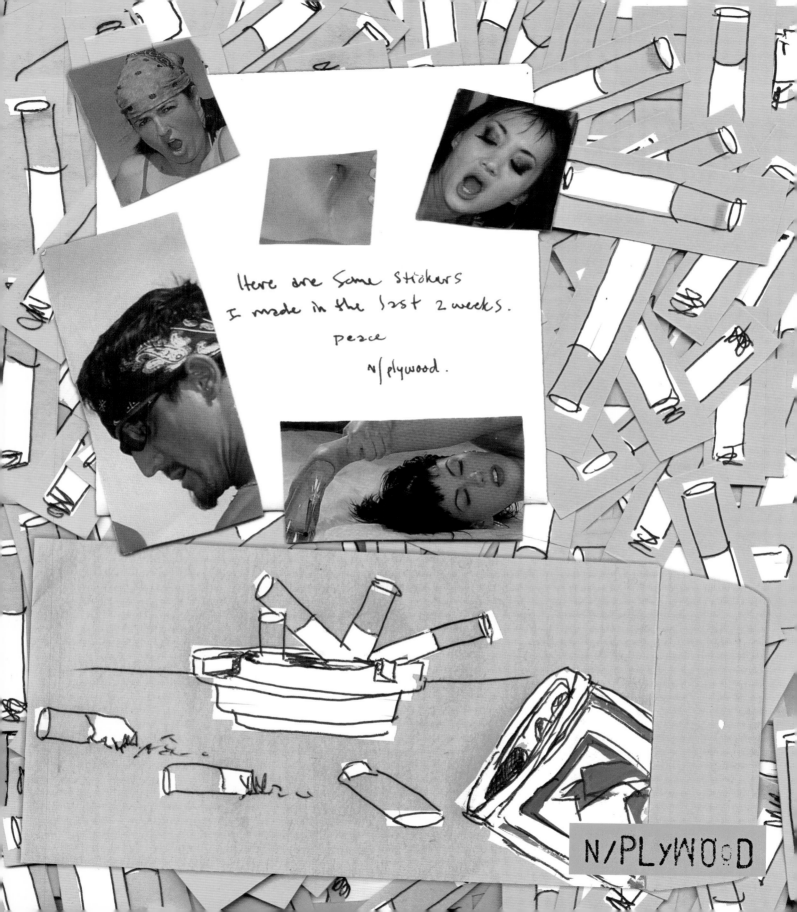

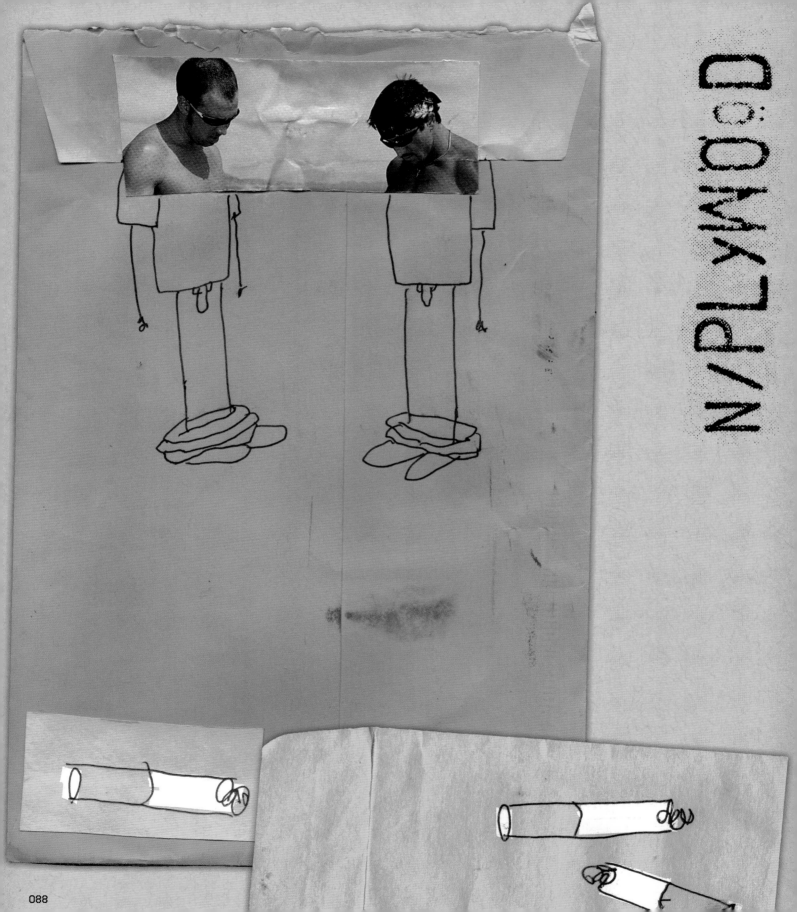

In addition to your wooden stickers, collage is another medium in which you choose to work. When you place images of people and objects in different contexts they take on new, often humorous meaning in your pieces. How does this process reflect you and your experiences?

I am a collector of everything. My basement is full of cut out pages from various magazines, photocopies of images in different sizes and shapes. They kept piling up so I decided to do something with them. So what better idea is there than to put these pages on envelopes and mail them to people all over the globe. Viva dumpster diving!

Upon viewing your work, one might conclude that you have an unusual perspective. (They might even think you're a little strange.) How do you respond to such assumptions?

I don't know how everything comes about on paper but I work independently as a janitor so I have plenty of time during the day to warp ideas into semi-perfect forms of expression.

What can we look forward to from you in the future?

Bigger, Better, More, Wood, Paint and Blood.

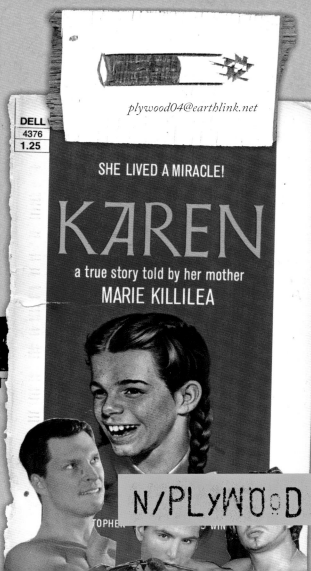

plywood04@earthlink.net

DELL
4376
1.25

SHE LIVED A MIRACLE!

KAREN

a true story told by her mother
MARIE KILLILEA

Karen was gifted with the Ability to Convert gay men into Hetero love slaves.

N/plywood.

N/PLYWOOD

SESPER

When did you get into stickering and street art?
I started to paste up photocopy a4 posters in 98/99 after seeing some stuff on the internet and in skate mags. In 99 we saw the Phil Frost documentary video where he pastes up original works in some small boxes and shows all the process to create the posters. This blew my mind and he's still one of my favorite artists. My friend Flip helped me a lot to develop some posters and stickers skills too when I met him in 99. Talking about drawing, one of the first artists that I knew is a Brazilian guy called MZK that used to make fanzines and comics in 1989. He showed me some great stuff when I was 16 years old like big handmade posters and stuff like that. I started to paint my style in 96/97. At this time I was crazy about the artwork that Rich Jacobs had done for the ICEBURN records sleeves and he was a big influence at that time. Back then I used to paint a lot of cardboards, wood, recycled stuff and different kinds of ink and paints. I turned my head more into the graffiti stuff, not doing pieces or letters, but assembling the cans, markers, stickers and the style to something that I have started for myself working more as a therapy.

What's the scene like in your city?
Sao Paulo has a great scene for art in general. Nowadays there are 5 different underground art galleries and a lot of good places to see something in the streets. The cops are more tolerant with graffiti nowadays too. People that I think represent the stickering attitude here in Brasil are: SHN, projeto cha, fat louis, digital pimp, homem bomba, rafo, onio, joao lelo ...

What do you do in your day job?
I wake up early every morning at 6:50. At 7:30 I leave my daughter Rebecca at school at 8 a.m. I get to work at Venom Clothing at 9 a.m., creating artwork for tees, products and ads for them. I leave at 18:00 get home at 20:00 and work a little bit more for Most, a brand and a store art gallery that we've been developing since 2002 with my partner Flip and around 00:30 I go to sleep. During the weekends I travel with my band to play shows around Brasil and do some art stuff, its been like that for a while. I always find some time during the day to do some stuff for me, that's for sure.

Do you find it difficult to balance work / family and personal life / your art?
Yeah no doubt! But my wife, my family, and the people at my job are very supportive and help me a lot! Nowdays I'm more into computers because I work in front of one for more than 10 hours a day, so if I'm not in the office I'm at home, but as I play in a band I have the chance to travel to different cities during the weekends to play shows and this is where I take some time to paste up and do some artwork in the streets. I don't hang out at night or go party.

What is the relationship in your opinion between skate culture and street art?
I started skateboarding in 86 so I saw a lot of graphics on the decks made without computer skills, but I only figured out the real sense of Art in the skate community in the 90s with Gonz, Ed Templeton and some skateboard magazines that published some artwork inside, I think the skateboard spirit of DIY gave art a way

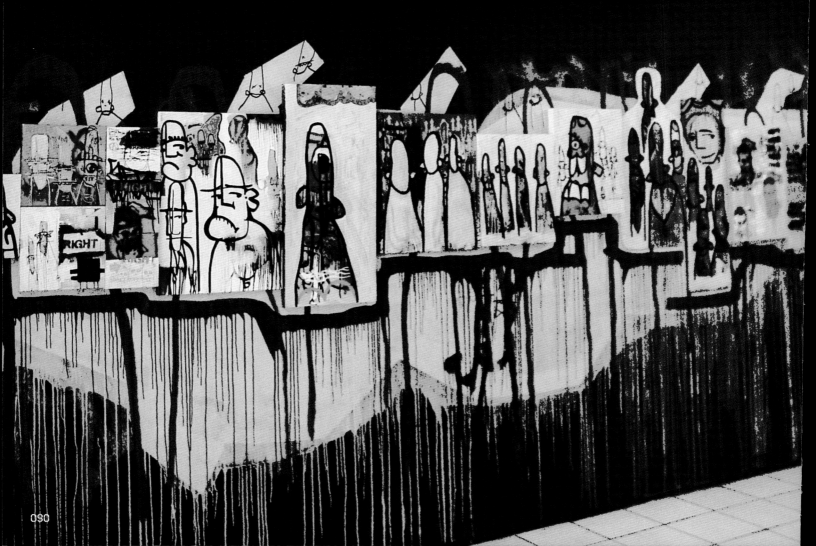

In your work you draw animals such as cats and other creatures. What is your connection with animals?
I like other animals as well such as birds and crabs but I can connect easily with cats. I'm like a cat, wandering around senselessly, until a few years back I have purpose in putting up my stuff anywhere I go.

Do you have a cat?
My dad has a coffee shop and a gajillion cats have come and gone since I was a kid but this one particular cat that I liked stayed for 3 generations till her great, great, great grandkittens and then she passed away...too old. I missed her.

In your art how do you create interaction with viewers of your work?
My earlier stickers are like comics/manga. The characters shout "Look out behind you!", "Hurry up, they're coming!"or "Pull out!, I repeat! Pull out!!" They're trying to interact with people warning them to be cautious...

Do you have a favorite comic book?
Tankgirl is my earlier inspiration and Jim Mahfood's Grrlscout and lotsuv other mangas like "FuriKuri".

Your work is very versatile, ranging from vector computer graphics to aerosol graffiti art. With all those styles, do you have a favorite?
Vector, I like my SaikoNeko characters, my very 1st experimental one incorporating graffiti and characters, and my fav graff piece is a woman dancing on a shop pillar... and for stencils the street artist arms hanging out from the cell and my handrawn manga style stickers...

What do you do on an average day?
Work. Freelance work, illustrations from small stuff for brochures, illustrations for local international design magazine "Territory", experimenting with characters, most of the time I doodle & sketch. Weekend stickering around.

How would you spend your perfect "dream day"?
I want to experience what it is like working with Devilrobots as a character designer in Japan... Having lotsuv money and travelling around Japan doing street art or Collabo with other international artists or doing snowboarding but there's no snow here... or travelling to Europe if i had the money.

What will we see in the future from you?
Illustrations, characters, throwups, pieces, tshirts, charcaters, paintings and characters, characters, characters and characters.
...and illustrations too.

For more work by Shieko visit
www.supasoniksnailstudio.com

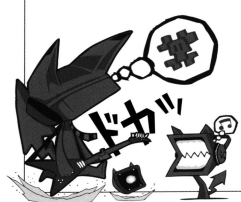

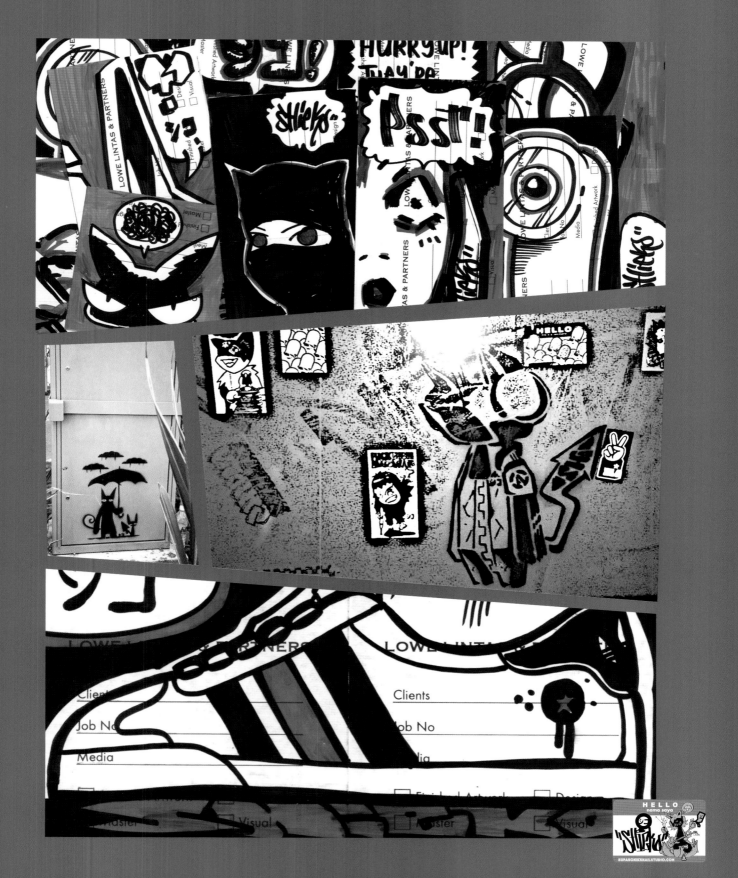

DEFEND AKASTONES

HAVE YOU

CHAN

SEEN HIM ?

HAZCHEM.NET

EVILOS
vs Sticker Dealers

F*CK **Ordinary**

5BOROCLOTHING.COM

SABOTAGE

Go outside!

RENEGADEPENGUIN
.COM

The
MadOne

Mobbin The Urban Society Since 1998.

Be Human

newyard

collabo::delae::series

NANO

allostinthought.com

http://www.myspace.com/hoodednomad

MAD

http://www.myspace.com/hoodednomad

cnprototype
inspirecreativity.com

E.5.CHARLIE

www.e5charlie.com

SPLENdid

MYSPACE.COM/SPLENDIDCOLLECTIVE

trust

DEL

DOLLA'LAMA
WISDOM

STUDIO138·NET

Dudzinski Design
lainer@mac.com

M*I*G*R*A*N*T*E
www.migrante.net

BVIKB71

coallus.com

crevicecreeps

UFC
JAO
DMC
WOTS

FATT-ED
FATT-LID
FRUIT

BARCODEART.COM

OBEY

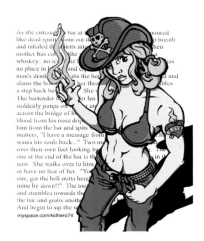

myspace.com/kidhero74

sht!

MYSPACE.COM/
SHTEXCLAMATION

RIPPER1331

I ♥ PIXELS

UNDERSPRAY.COM

the
NEW POP

THE HENLEY COLLEGE LIBRARY

SUPER BOLD OIL-BASED
PERMANENT PAINT MIXTURE.
JUNOBOPAINT.COM

junobo.

J.STONE

BONZO

DEMON
PACK
.com

clmeisinger.com

Urban
Communication
Mission

MAD
ONE

LCV4
10 Tartar Road,
Cobham, Surrey,
KT112AP, UK

MAiLmeART.com

[nano] vs clickypenpixie

MONK

INTERNATIONAL SMUGGLER

BLACKBOOKS
S T E N C I L S

remindstudio.com

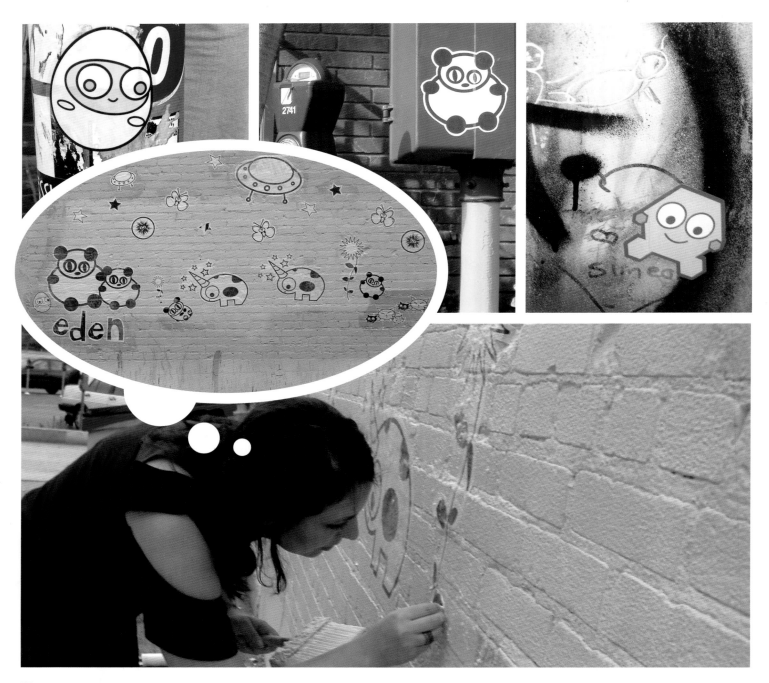

How did "prank calls" on early chatrooms lead to your adopting the name olive47?

So here is the legend of olive47. In 93 I was living in Savannah, Georgia with 6 guys in a big house next to the park. My housemate's girlfriend at the time was obsessed with baiting pervs in chatrooms. So he asked me to go in and start messing with her... well, cause I'm kinda good at that stuff. Anyhow, so we kept trying signon names, and they were all taken... so after about 5 tries, olive was a random name I chose. d tacked on the 47, and so it was born. Around the same time, I was having a show of my paintings... I'm a really shy and private person, and putting my real name on the flyers made me feel all sick inside, so I used that instead. I like it because it was completely random, and I'm a bit ADD, so I always have to have tons of different projects going on at once... printmaking, painting, sewing, and jewelry at the time... beyond that, when I do more image based paintings, I always do a set of 3 or 4 abstracts along with it to keep my mind loose... so it seemed like a good way to cover all that.

A side note: I hatttteeee olives.

How did you get started doing street work and why?

I very first started exploring the ideas of street/public work in Savannah in the early nineties. My housemate would do these drawings in chalk on garden walls near our house about one of our professors, who was a scotty dog. We would put the dog in harrowing situations in the drawings... and the title was always "pressure and a (fill in the blank)"... it was just a private joke with us. After that, I was into doing these little xerox colleges using a lot of pictures from 50's and 60's paperbacks.. they usually involved some sort of "freak", like the wolfman and then insects, like lice or beetles. I would do the collages, and then run off like 100 of them and post them on telephone poles or just leave them with other flyers at coffee shops. I don't know why I really did it beyond curing my own boredom.

I started doing my own stickers in 1999. In the years before, I was always the one designing stickers for the companies I worked for, and became aware of the aspect of fun that they brought to others. Around the same time, with the exception of Shepard Fairey's work, the only stickers I would see on the streets were adverts for trainers and hip hop bands. I was using a lot of sperm imagery at the time, and just thought it would be funny to see pink sperm on the streets... advertising nothing but image.

For me, it was a way to show my work without going into a formal situation. My intent isn't one of self promotion or trying to get famous, it's just a way to do my job as an artist on my own terms. To be anonymous, yet express image to others. I also enjoy the aspect that people who wouldn't go into a gallery would maybe see the work... approaching art on a more public/pedestrian level. Make people think a little more about the environment around them... like if they saw a sperm unexpectedly, what else was out there that they weren't noticing.

Was that when you first began creating your characters?

I don't think of myself as a character person... I'm more about creating an entire environment for them... an eden of sorts... I was really shy as a kid and was teased cause I was bookish and artsy and weird, so I always liked animals better than people. My parents tell a story about me saving all the money I had in my piggybank and bringing it to them after one night where I had a dream where I had a pet skunk, and begging for a pet... even a butterfly. I've just always drawn animals, and environments for them. I don't remember ever not drawing. My dad

makes paintings and drawings, so we always made artwork in the house. I grew up on a mountain suburb of Chattanooga, TN. We had a huge garden and our house was next to the woods, and I would go play in them. I had a crazy imagination, and thought fairies and leprechauns and all that lived there... I would go searching for them for hours... I think it all comes from that. A lot of the objects and animals I draw, I've been drawing for years and years. If you were to look at my work as a whole, it's basically a 33 year old narrative about my upbringing in the south and influences from there and my life here in Los Angeles sometimes figuratively, and sometimes literally. For example, the UFOs... the mountain across from mine was one of the top UFO sighting places in the southeast and on my mountain, there was a house halfway up that was shaped like a UFO, so we had to pass it everytime we'd go to town. I'd imagine what it looked like inside and it was somewhat of a mystery and playful. Most of the stuff I make now is just a progression of the same themes as it all comes from what I take in in my daily life.

A couple of well-known religions have their headquarters near Chattanooga, did they have anything to do with the inspiration for the Children of the Multiprisimed Light, the fictional cult you started?

Short answer: no.

Actually, I was raised in a very liberal Episcopal church. I was always given freedom of thought when it came to my spirituality, and taught that if you aren't questioning and investigating your existence, then you're probably missing the point. I've explored religious themes in my work since high school but that came more from the fact that half my high school went Ultra-Christian after the suicide of a classmate. It became like a huge social club, and if you didn't go to the bible studies, etc, you weren't following "the right path". I had so many people praying for my soul in my junior and senior yearbooks, it became a huge joke. Then in art school, I was a painting/art history major, and most of the important works in early painting are religious works. For hundreds of years, it was one of the main subject matters in artwork. I actually made a full set of objects for a religious ceremony using a set of symbols I was working with, and also did a series of paintings taking well known religious works, such as El Greco's Crucifixion and Rosetti's Annunciation, and fooled around with the symbolism, replacing objects and creating new narratives. (Symbolism is extremely important in my work.) So fast forward 10 years, I'm living in LA, and I had unknowingly dated a Scifitologist for a short while; and at the same time, my landlady and her husband were involved in an intervention to rescue their 30 year old daughter from a cult down in San Diego. When Halloween came up, it just seemed like the thing to do.

Was your intent with starting the cult just to mess with people?

My intent was purely satire, and curiosity to see reactions of people... some people are really freaked out by it, but I'm pretty sure they lack a sense of humor. The cult is more of a humourous commentary on religion and cults (and the interchangeability of them). It started off as part of a Halloween costume, actually.. I was a cult member... with a small handbulletin and I put a little web address on the bottom, and then I thought I should actually really make the site, so I sat down with a bottle of Jack Daniels (my favorite: Jack and ginger) and wrote the site in about an hour. I have to say that also, I think many Christian churches are like cults as well, so the cult was in ways more about organized religion in general. How people blindly accept ludicrous proclamations and make blanket judgements in the name of faith. It's just all so hypocritical and not really about "God". So part of it was also about writing the most ridiculous things in a convincing manner and about how people will blindly join something, even in the name of humor. Cause

who knows, I could really be some egomanical supergenuis with real goals of world domination. So it really wasn't about messing with people, but more about the issues of the marketing of religion, the reactions of people who join/don't join/email me threats of damnation to my eternal soul (which all come from Christians). So a lot of the influence was growing up in the bible belt, but Southern California, particularly orange county is super religious. Like most of my work is basically about religion/mediation/eden just put forth in different forms using tradtional and non-tradtional symbols.

Was it a difficult transition from growing up in the suburbs of Chattanooga to college life in Savannah?
My family actually moved from Signal Mountain (and mind you, it's not like I lived in the sticks. I lived in the smallest house in an old money neighborhood full of mansions), to Knoxville, which is a larger city, when I was about to start high school. I went to clubs downtown when I was underage, cause I was tall and looked 18 when I was 15. I worked for a gay couple in their interior decorating business, so I wasn't sheltered or backwards or anything. I'm a really independent person, so moving to Savannah for art school was easy. I was ready to be out on my own. When I moved there, downtown was still pretty much a ghetto city with pretty houses. The only thing I really had to get used to besides the smell of the paper factory was the pregnant hooker whose "territory" was the street behind my house. The only thing that was hard was that there weren't really any record stores and at the time, there was maybe one venue to see live music.

What about the move from Savannah to LA?
From Savannah, I actually moved around the country for a year or so, living and couchsurfing in Portland, Seattle, Atlanta, and a couple other places. Me and my car went cross country 5 times. I was actually moving up to Seattle when I stopped to visit some friends in LA, and they convinced me to stay here, so I've been here 10 years now. I've made a lot of good friends, and found it a fairly easy existence. Los Angeles is what you make it... it's not what it looks like in the movies and tv... yeah, that part is there, but it's easy to avoid. Next, I'd really like to live in Europe, preferably Amsterdam, but I need money or some person to adopt me. (hint, hint)

What one thing did you learn as a child that you have taken into adulthood?
Believe in nothing and believe in everything, cause we could just be characters in someone's dream and be gone in the instant they wake up. (My dad was really into The Twilight Zone.)

What are your thoughts on the increase in plastic surgery?
I live in Los Angeles, so I see a lot of it being done for purely cosmetic purposes. While plastic surgery is appropriate in some cases, like escaping international hitmen who have a contract out on you, or fixing that "deviated septum"... for the most part, I think it's really damaging. It brings about and panders to unrealistic ideals of the human body. It teaches one to be unsatisfied with themselves in one's natural state. And a lot of really scary looking monsters are being made.

What one person do you think this world would be better off without?
Carrot Top. I don't think I need to explain.

For more olive47 visit:
www.olive47.com

Danger

PRIORITY
MAIL
UNITED STATES POSTAL SERVICE ®

www.usps.com

TO: Venus

TES POSTAL SERVICE ®

From:

www.usps.com

.Tenderloin
Gun Club

TO:

Label 228 July 2002

When and how did you acquire the name "Venus"?
I acquired the name Venus back in '97 when I moved to San Francisco. My only friends were skater boys and that's who I really befriended at first. They were all into graffiti and skateboarding so that's how I got into graffiti. I loved what they were doing. I'd never tried it before so I gave it a shot and I loved it. I loved writing on shit that didn't belong to me. It was great. So they nicknamed me "Venus" (I'm not sure why exactly, but one of the guys that named me had a crush on me so I think it had to do with that) and it stuck with me ever since then.

Did you skate and do you still?
Yes I did skate back then, but I stay away from the skateboard for now. I don't think I'm as coordinated as I was back then. So if I skated now, breaking a bone would be too easy.

Besides making your own art and Short Cuts Zine, with what other projects and crews are you involved?
Well, I'm involved with a few things right now. I've just started a crew called OTP (Obey the Pussy), which is a collaborative / crew of down females. So I've been designing some stuff for us - Queen of Hearts Design (www.burndem.com/quofhede.html). I'm also involved with a mural that is supposed to go down here in SF called the Lilac Ladies (www.lilacladies.org). It's going to be a two block long ladies' mural in the heart of San Francisco's Mission District (24th and Lilac - behind the McDonalds). We're still working on permission so we're unsure when this project will start. Currently, I'm 7 months pregnant so I'm not tackling too many projects at the moment. I'm too busy trying to mentally prepare for motherhood.

Obey the Pussy sounds hard and a little tongue-in-cheek at the same time. Is that the intent and how did you come up with that name?
I love seeing the reaction to the name Obey the Pussy. Some people laugh it off, some people do a double take, and some people just don't get it and get offended. There really isn't a special story behind the name. My husband and I were drunk one night in the Tenderloin in San Francisco and I think we were yelling out obscenities. In that neighborhood, it's normal. I totally screamed out "obey the pussy, bitch!" to him and we both started cracking up. It's a miracle I remembered it the next day and I started running with it because the saying itself is quite offensive, I must admit and that's the main reason why I love the saying. I used to (or I still do) do a lot of art with typography and most of those words were swear words. I love the shock value that a single word has. I guess I don't really like to offend people but I really like to surprise people with offensive words in pretty fonts. People can take OTP as it is. I take it as literally Obeying the Pussy. We're a crew of a bunch of hardcore, down artists/gals that get down (whether it be for graf, art, photography, etc). The saying literally fits us all, we're all strong independent women that don't take shit from anyone. Most of the girls that are in the crew are my fam, really close friends that I've known forever.

How many members represent OTP Crew?
Some of the girls that I put in are new.... currently we have 26 girls repping OTP and we're pretty much cross country.

Queen of Hearts is a great name. Is that just you, or are you working with other artists as well?
Well Queen of Hearts was directly connected to Obey the Pussy. Everyone wanted to get shirts done. So I collaborated with my friend Paula who runs the burndem site and also runs a sign shop in Cincinnati, to start up a mini site where people can buy Obey the Pussy tees, hoodies, bags, and other goodies. My first design was the girl, that did really well. Shockingly, people wanted to buy it (even boys). So I thought why not create a new image, a more harder image than the girl to represent what the crew is all about so I created the brass knuckle image (with a little help from Paula to clean it up).

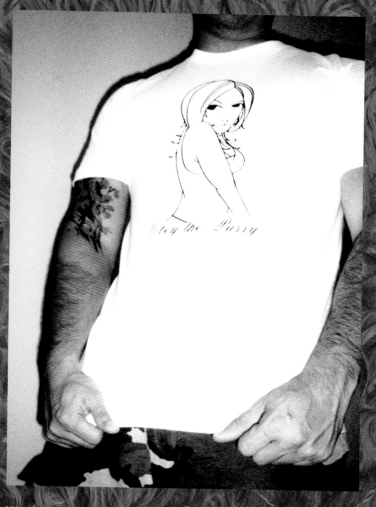

What are your plans for Queen of Hearts?
I really don't have plans for Queen of Hearts Design set in stone yet. I would like to have the other girls that are part of OTP create their own Obey the Pussy image and possibly sell tee shirts through Queen of Hearts Design. That idea has been thrown around a bit so I think that most likely will happen sometime in the near future.

According to the website the Lilac Ladies mural will be the city's first all-female massive mural undertaking and will help revitalize a degenerating area. Can you tell us more about that project?
Yes, Lilac Ladies will definitely put us on the map. My best friend had this idea for years and just currently decided to take matters into her own hands. The biggest struggle that we've had so far is getting permission. It's been hard tracking down the actual owners of the building; some people don't know who owns the building, sometimes we have to go through people just so we can find out, and some people don't speak any English. Most of the time the language

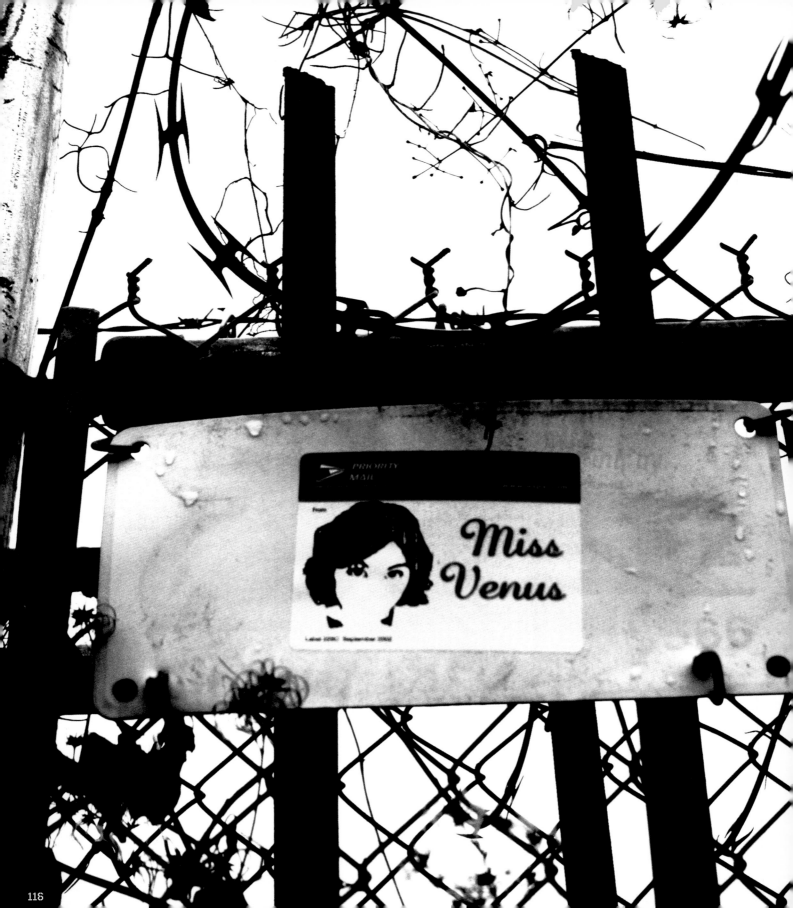

barrier has been the problem and has been really disheartening to us. For some reason, we don't have any friends that speak fluent Spanish, so getting someone to go around and translate for us has been hard. Just recently, my colleagues had a meeting with the director of Precita Eyes ("non-profit multipurpose community arts organization that has played an integral role in the city's cultural heritage and arts education") and she agreed to help us out with our vision. Precita Eyes is known for their murals all over San Francisco so getting her to back us up was a big step for us. Also, as far as raising money, we had a benefit art show in August 2005 and we raised nearly $1600, which is a great start but we still have a long way to go.

How can people help with donations, language translation support, etc?
I suggest that if anyone wants to donate money or donate time, you can contact one of us through the Lilac Ladies site at: Lilac Ladies MySpace: www.myspace.com/lilac_ladies_mural_proj

To bring it back around to your own art, when and why did you add stickers into your arsenal?
I've always done stickers, but just the tag ones on "hello my name is" labels or name labels with the red or green borders. I didn't start doing elaborate stickers till I think, 2000-2001. I think I was going through one of my many doodling moods at that point, and I met my best friend who is heavily into stickers. I think she kicked me down some one night and I started doodling on those and sticking them up around her house. If you've seen her place, you'd understand. She has stickers all over the place; on her bedroom door, her kitchen door, her art desk, and even the outside and insides of her fridge. Stickers is probably the most easiest way of getting up a lot, and that was what appealed to me the most. Around then I started adding color to my stickers and making them even more elaborate and even though it took time, it was cathartic for me to just sit there and be in my own world making stickers.

What do you attempt to convey to viewers with your female characters?
Ever since I've started drawing, I've always done characters. I didn't start doing girl characters till high school and it came to me naturally. Through time, my characters have evolved; they became much more womanly and got that undeniable attitude. One time one of my friends came up to me at my very first art show and told me that the characters were starting to look like me. I think unconsciously, I started emulating my characters after myself. My characters are undeniably sexy with a lot of curves just as a lot of women are and I think that is what is appealing to my viewers, men and women. I like to show my viewers that my characters are strong and with much attitude, they aren't your regular girl next door characters, they're much more than that. My characters have much cleavage, tattoos, an angry face... I hate to draw characters that look "girlish". Womanly characters are much more appealing anyway.

Is there anything you would like to say to any female artists (street or otherwise) who are feeling intimidated about putting themselves out there by showing their work?
That's a good question. Don't be intimidated at all. The whole "game" is male dominated sure, but just because it is doesn't mean that you can't do it. Prove yourself to them. If you don't feel like your work is up to par, just remember everyone starts somewhere. I warn you that it won't be an easy task so you have to make sure that you are doing this for the right reasons rather than the wrong. People will talk shit, people will hate... but there are haters in every game, don't worry about them and keep looking forward. Don't let them get you down. Just keep at it and before you know it, you'll be doing this for years and you'll by then have your own style. I sound like a cheesy cheerleader but I was totally intimidated when I first started. People were talking shit and it really hurt. Through the years, you learn and you grow and no one can take that experience from you. Being into graffiti/street art has been one of the most positive things that has happened in my life. I don't regret any minute of it.

As a soon-to-be mother, if you were given the power to change just one thing about the world in which your child will grow up, what would be that one thing?
Well I gave a lot of thought to this and I can't come up with a straight good answer. I've noticed that a lot of children grow up so fast. I grew up in the suburbs near Chicago and I can safely say that I've been "protected" from most things. My parents were very strict and school was my major concentration. I never really got to date or go out with friends as often as I'd like to but I never questioned their authority. Then I move out to San Francisco and its a whole other world out here. The children here grow up so fast. To me, its kinda sad to see a little girl swearing at her parents or to see parents encourage their little ones to insult people. I don't want to overprotect my child from everything because there's a lot to learn about in this world. But I would like to have my child slow down and enjoy his/her life rather than trying to get through it so quickly. I think that's what I want the most being a first time mother. My child will have a whole life ahead of him/her. I don't want to see him/her rush through it and grow up so quickly.

For more Miss Venus visit:
www.myspace.com/venusone
www.geocities.com/shortcutszine

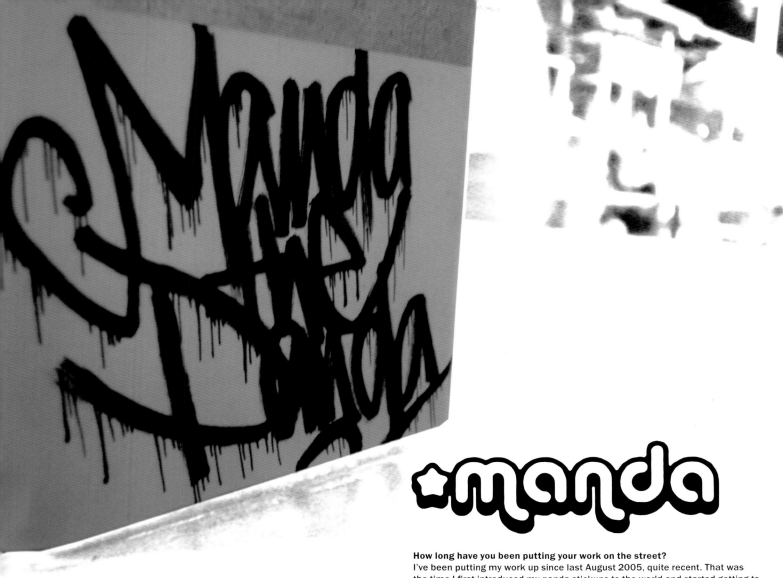

*manda

How long have you been putting your work on the street?
I've been putting my work up since last August 2005, quite recent. That was the time I first introduced my panda stickups to the world and started getting to know different artists here and there.

Did you have any initial fears or concerns about taking your work to the streets?
Of course I did! Over here in Singapore the law is stringent so everything is rather constricted I suppose. I mean we even have a ban on chewing/bubble gum... Anyway, first time I decided to bring it to the streets, I just went ahead and did it. What's life without taking risks I say.

Who or what inspired you to start?
I had a friend who was doing street art extensively and one day he saw my doodles in my sketchbook. He encouraged me to develop my character more and bring it to the streets. From there I started to explore more mediums and work from various illustrators and designers.

What's your connection with pandas?
My friends affectionately call me "manda the panda" just cos it rhymes. And I never seem to sleep. Hence the dark eye rings. It went on for a couple of years,

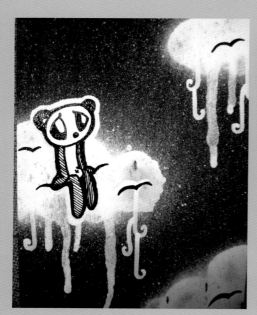

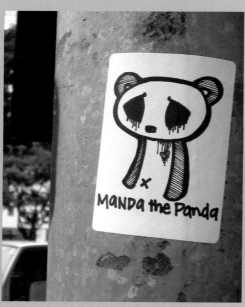

and when I would write letters or cards over I would sign off with a little panda sketch at the bottom. Soon I started doodling a lot of pandas everywhere! Pandas to me are symbolically Chinese.. and well, I'm really Chinese... so I guess that's some connection there... Pandas seem like rather peace-loving creatures as well so it was easy for me to shape a certain kind of personality a little close to mine.

Your panda characters often seem pensive, melancholy, even sad. Is that how you would describe yourself?
In some ways I suppose. I'm actually rather loud and spontaneous in person but mypandas started out as something rather personal to me. I doodled a lot when I had my bad days so it was some sort of release. Eventually it just naturally moulded it's personality, and stayed the way it was.

What would you like to convey to people who encounter your work either on the street or in a gallery?
Well, that behind that panda lies a stranger out there, who can be just any regular person on the street. My panda could be anybody! Even that old man selling ice cream in a corner. Keep them wondering I guess. But honestly, I just hope that my character would bring some form of joy to anyone who sees it. Even though it might look very sad at times. I'll be satisfied if my work even catches anyone's eye. Nowadays everyone's just so busy they just zip here and there without taking a breather even to look at the surroundings. Especially in S'pore. Now that's sad. Art in the middle of a concrete jungle. Perhaps it could just remind them to get out there and spread some love and smile too. -smile-

How would you like your work to develop artistically?
Well, I'm still learning a lot. Everyday. Besides spreading my art on the streets I do jewelry/ metal smithing in school too, so I really hope I can combine these two elements together in the future as I progress. And further develop my character as well and branch out.

For more manda visit:
manda-ang.blogspot.com

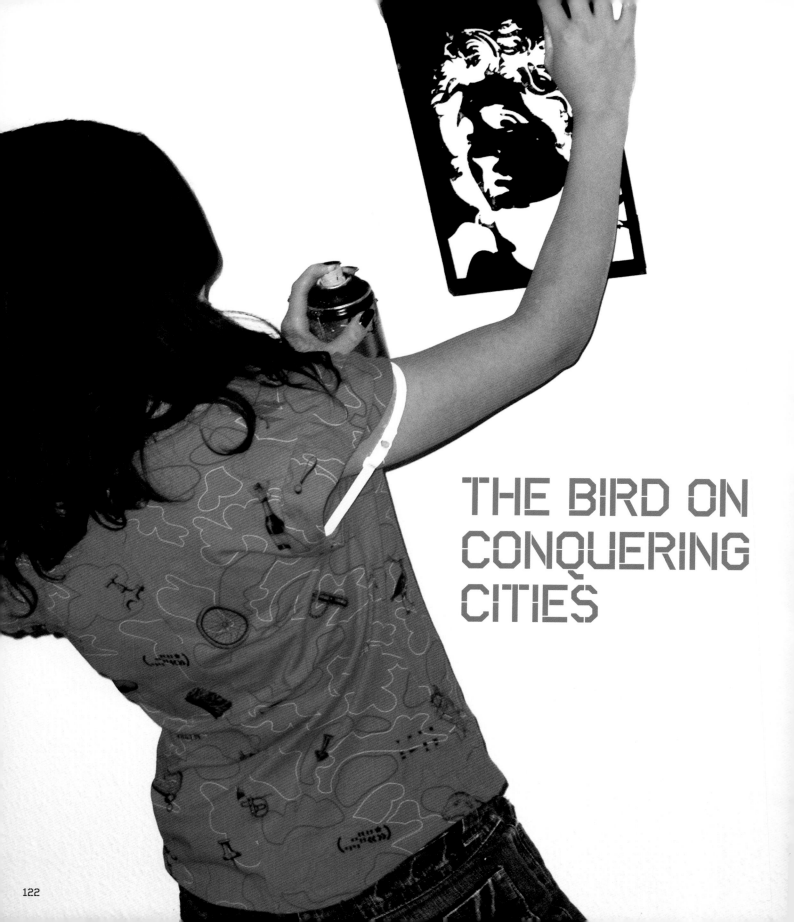

THE BIRD ON
CONQUERING
CITIES

How and when did you get the name The Bird?
I gave myself the name "The Bird" when I was 15 but I don't remember how I came to this name. I guess it was because of one of my characters called "Birdy".
I tagged this name everywhere and so eventually Birdy turned into "The Bird".
I like this name. For me it's a synonym for freedom.

How did you make your very first stickers?
That was fun! I was such a dilettante! I drew my characters on normal paper or printed my photos and then stuck my small drawings and photos with a gluestick on the spots.

Were you doing that on your own, or were you inspired by other stickers you'd seen on the street?
I was not inspired by the stickers on the streets because my friend "le chat" and I thought we were the first ones to make stickers and put them on the streets. Then, the first time we went on a little tour, we noticed that there were already hundreds of streetart stickers on the street. We felt really stupid that we did not notice stickers before!

Do you think that was a good thing?
I did not know that there was a scene. And that was good. Otherwise I might have begun to make streetart for the wrong reasons, influenced by false meanings about it all.

How do you make your stickers now?
Because I have so many different stickers I use several different techniques. The art on my stickers are almost all hand-made (with stencils or hand drawn). I have got also some graphic designs. Other stickers are 3D. I use special double-faced adhesive tape when I want to stick those up. I have got dozens of old telephone-cards, floppy discs, CD's and videotapes. I use them for underground. Then I spray some stencils on them or I glue different things on them, like 3D-puzzle-pieces and such needless things. It's all about the message, forms, colours and compositions, when I make my stickers.

When did you start doing stencils?
I started to do stencils quite early. I saw a lot of different stencil works in Bern and thought: This stuff looks so cool. I also want to make stencils. I had no idea how to make them, so I experimented. Later I found out that the streetartists from Bern are all using cartons for their stencils. I always used and still use transparent foil to make them. You can use them over and over again (hundreds of times), when you know how to treat the material the right way...

Does Alexander the Great have an important meaning for you?
Yes. Old tales and sagas always mesmerised me. High School was the most boring time in my life, so I would always bunk off school, go to the library and read dozens of books, all telling different tales, different sagas (reading the tales about Artus, Alexander the Great, Gilgamesh, die Nibelungen, and a lot of other Celtic

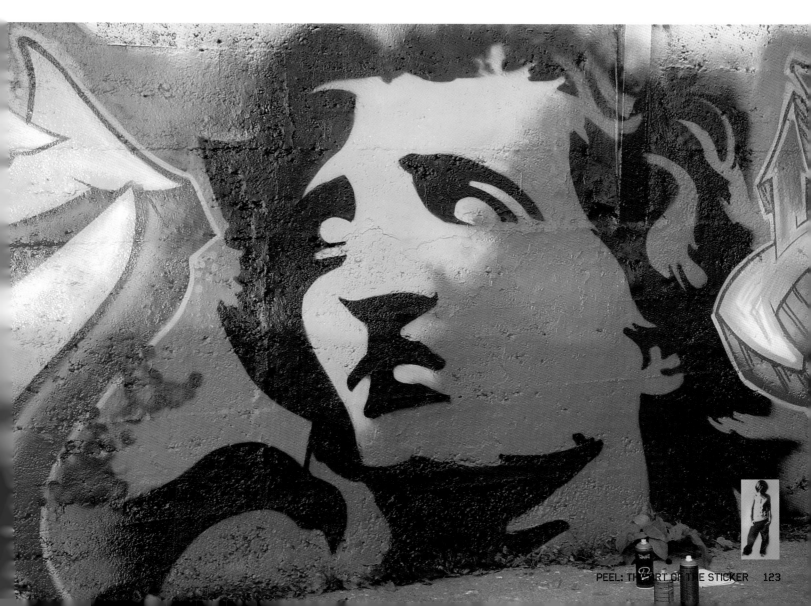

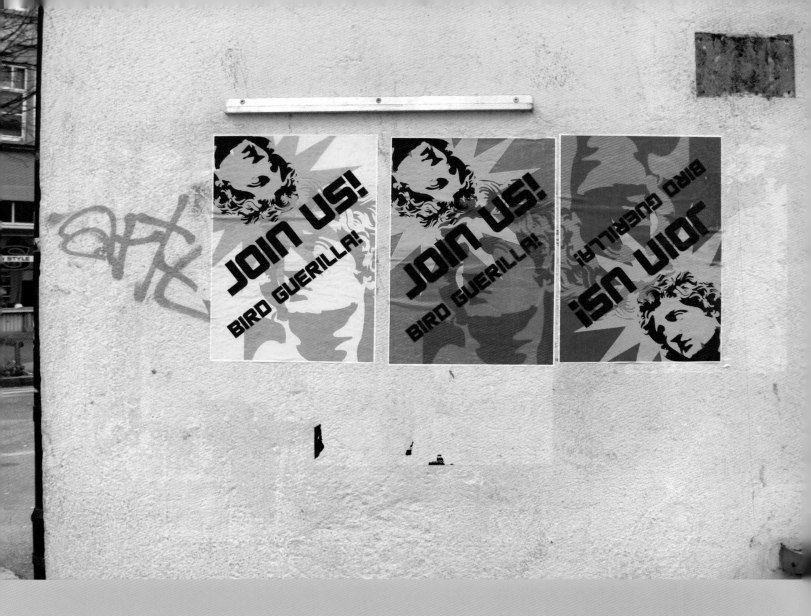

what i do is CONQUERING different CITIES with my STICKERS.

and Nordic tales) I decided to make a sticker from Alexander because his person fascinates me. He and the tales about him always crossed my life, even before I was born (my parents wanted to name me after Alexander the Great). And now I've chosen Alexander also as some kind of a fellow, that accompanies me when I make my Street Art.

Alexander the Great is for me the embodiment of power, pride and charisma. He is the active, offensive energy, that tried to conquer the world. And what I do is conquering different cities with my stickers. It is just a different way, an artistic, guerilla-like way of capturing different parts of places.

Could you talk about your streetart adventures in Basel?
It was always very exiting. When you start to put the first stickers on the street you slowly fall in a kind of trance. First you talk a lot together, joking, telling funny stories but suddenly you are fully concentrated. Your senses are all sharpened, you hear every single noise on the street, you smell the different odours, your eyes only see the spots and your heart beats in a strange harmony with the street. You don't care if you are freezing or if you are tired or hungry. You just keep on going and nothing seems to be relevant, except the art. Take a new sticker, peel the

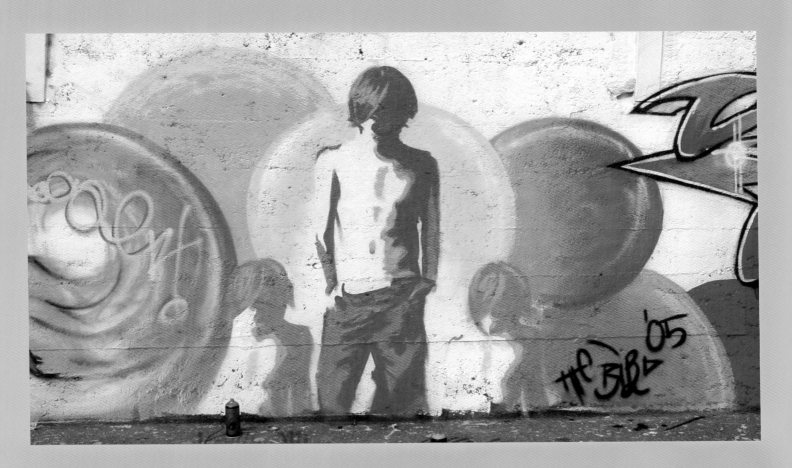

you feel like PART OF THE CITY...
...and it feels SO RIGHT.

back of it off, stick it on a spot, take a new sticker, peel the back of it off... It all functions automatically. You don't think about it anymore. When you are non-stop on tour, 4-7 hours in a night, you change into a different person, and you only feel more satisfied with every single sticker you put on the street (and each bombing you do counts double).

The dangerous thing about this satisfaction is that you suddenly don't care about the people. You don't see them anymore. They are just supernumeraries in your game. When there's somebody passing your way, you don't care... So the results are sometimes very dangerous situations. Once, as we were full in our sticker-flash we did not notice that there was a big police van, coming straight toward us. I was climbing on a spot, put my sticks on it and did not hear my friend. Then as the police van was right beside me I looked directly in the van, jumped from the spot and began to cross the street very slowly. I knew that it was too late to run away, so I looked at one of the policemen, still crossing the bloody crosswalk, and tried to smile a smile of pure innocence, tried to look like a small, tiny innocent girl, while my heart was sliding in my boots. I had almost a thousand stickers in my bag and a lot of cans. Gosh, it was horrible. But the policeman just smiled back and they stopped in front of me then drove away after I reached the other side of the street. I was so glad that they did not react. I was so stupid to forget to check the situation out! Just a few minutes after this episode, a stupid taxidriver yelled at us and said that we are bloody vandals. So my friend yelled back (something like: "you

stupid ass, I'm gonna beat you up!"). We ran away, hiding from him, because he followed us (I guess he wanted to bash my fellow, or maybe both of us). This taxi driver was really obtrusive. So we decided to go back to my place.

What motivates you when you just feel like you have to get up and do your art on the streets?
It's the feeling you have inside that you must go out and stick or bomb! It's like a scream inside your soul that demands for an alternative way to express yourself. It's also the adrenaline you want to feel. Have you ever felt pure satisfaction? One form of pure satisfaction for me, is when you finally walk on a bridge in Basel to see how the sun rises after you were on tour the whole night. You feel the sunbeams on your face, and your heart is filled with pure satisfaction. You feel that you are a part of the city, you feel like you can control the city. You satisfied your hunger. And it feels so right. Man, that sounds like how I would speak of love, but you know, streetart is some kind of a lover for me. Of course I can try to explain the deeper meaning why we all want to express ourselves. It has got a lot to do with the demand for power (like Nietzsche's theory about it). But we finally all walk in a circle and we never come to an end.

for more of The Bird visit:
www.fotolog.com/thebird

COLABORATE.
(BECAUSE IT'S GOOD FOR YOU)

BY DAVE COMBS

For the last few years one of the most prominent emerging trends in streetart has been collaboration. As technological advances facilitate the free exchange of ideas and allow artists to effectively work together it's never been easier for two or more individuals in different hemispheres to collaborate on a joint project. Today an illustrator in Paris uploads their design to the web and moments later an artist in Detroit adds their inspiration. Within hours of its completion people around the globe are viewing the finished product on sites like fotolog and flickr. Though similar scenarios abound, some artists prefer good old-fashioned tangible stuff on which to apply their collaborative works as in Chris Chillemi's Thrilla on Manilla project. (robotswillkill.com) In this "Thrilla" of a project manilla envelopes are mailed from one artist to the next as each person adds their own bits to the piece. When artists work together the resulting collaborative works are often greater and more interesting than each individual artist's solo work due to the juxtaposition of different concepts and styles. And that's always a good thing.

As global economic social and political ties increase and many demarcation lines diminish, there's never been a better time than the present for us as individuals to reach out to our fellow human beings in the world around us. With just a bit of effort we can begin to gain insight and understanding into the lives of people of

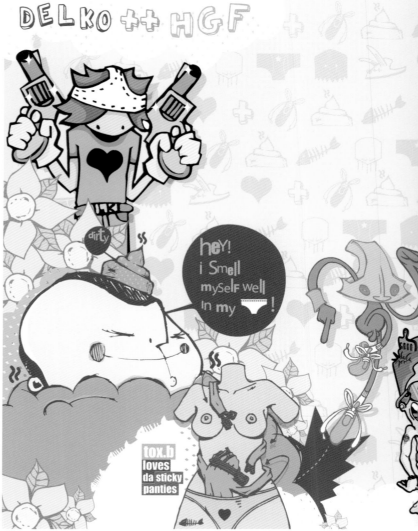

left: Esoteric Design vs. Robots Will Kill (Issue 5)
right: Delko Graphik Collaboration (Issue 5)

entirely different cultures backgrounds and customs. And that's a good thing too. What better way to reach out to one another than through our art?

With all this in mind we asked a number of artists about the how and why of their collaborations, and their responses which follow both confirmed and strengthened our case for collaboration.

Michael Pilmer
Collaboration is the nature of the "I threw up." sticker project. The stickers don't really work by themselves. They need a target image. Target images are usually an image of a person, or some kind of personified object.
www.ithrewup.com

FooB
aka LukeDaDuke
It's always fun to work with other people, I guess. You can share visions and image material and you can get a new look on things as the other artist always has a different method and view on how to work.
www.fotolog.net/foob

MCA
Evil Design
I like seeing my characters twisted in a way that I may not have thought of before. It is a good way to expand your designs and vision.
www.evildesign.com

EWOS
I think with WOOD I like to work the best because my work is dirty and raw and his is a straight up logo style, very clean...although I know his dirty style as well :-)
Also with mamacita, for the same reasons mainly.
www.fotolog.net/ewos
www.fotolog.net/mamacitacrew

Erik Lopez
Art Blur
Each artist brings a unique vision to the work. I think collaborations often supersede each individual artist's work in quality, depth of imagery and aesthetic appeal. When artists combine their Talents, each individual steps up their game, so as not to be out-done and so that they impress their peer.
www.artblur.com

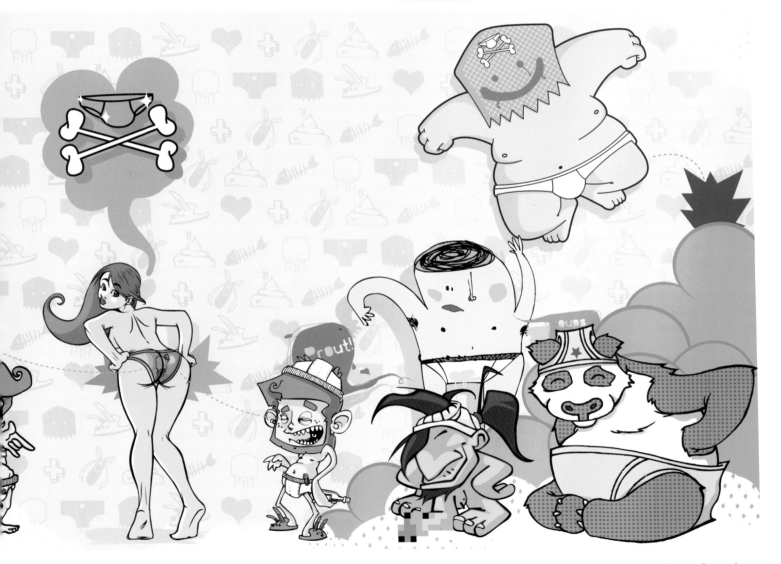

ilk, hey, tox.b, oktus, tizieu, maw, cat, gregos, ynepto, josh.

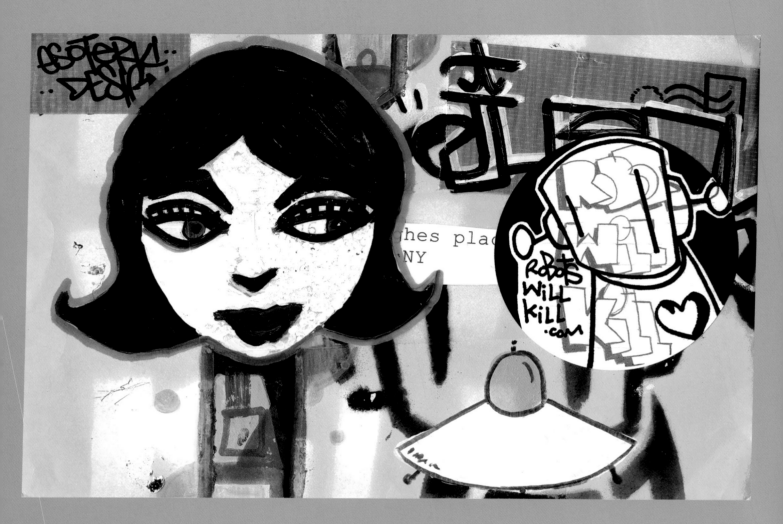

Capish

First, is to not stay alone, I mean, I need to have my eyes, my ears opened and directed to the whole world. That I live in France, is a like an opportunity, as many peeps told me... and I ask them why?
Cause, I know the social, political, artistic moods of my place and it's often a big bag of tricks or bullshit.... so when I start a collaboration with someone, it's an exchange of techniques, ideas, points of view, and also a way to discover and be informed on how things turn in different places. In France we're named it "La notion de partage" (the concept of exchange/ trade/ give and take, have/ receive), all those words, describing this concept is very important to me. To draw a parallel I am like one thing I can't live without: a 2cm round marker. I need to be refilled really often and this happens with all the people I meet. Refilled, I spread my new ink with a powerful and vigorous renewed enthusiasm.
www.fotolog.net/capish

Chun1

Through collaborating I have learned to be open-minded, and that the power of multiple creatives can be so much fun.
www.fotolog.net/chun1

Chris Chillemi
Robots Will Kill
I feel collaborating pushes my artwork to another level. Makes me have to step up my act. It makes you have to understand where they're coming from first and then your ability to exist with them.
www.robotswillkill.com

AzStar78
Project Vs.
I recently did some just for kicks digital collaborations with Marty Mar, Sife62, Abe Lincoln Jr... all smiles. But the thing that has hyped me up and out was Typestereo's Battlezine No.6: Alvaro Ilizarbe (Freegums) vs. AzStar78... I really like working on the Battlezine with Alvaro it was just straight up shit talking madness. All the Battlezine projects are amazing, got to give it up to Typestereo.

left page: Esoteric Design (left) and Robots Will Kill (right) Collaboration (Issue 5)
right page: (left) Various Artists Combo by Zoltron (Issue 7)
(right) DAVe Warnke Collabs (top to bottom) Dick Ripple, Chun1, Dick Ripple (Issue 5)

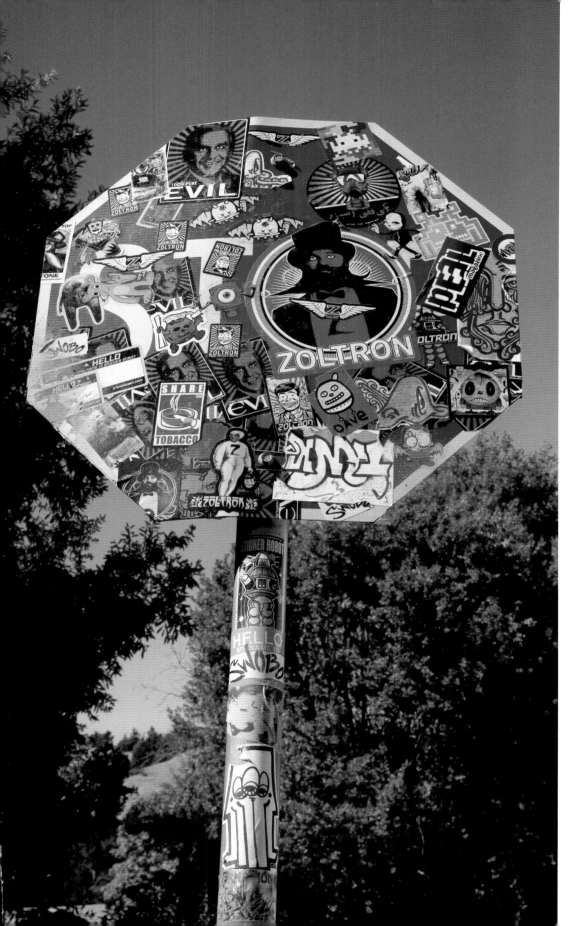

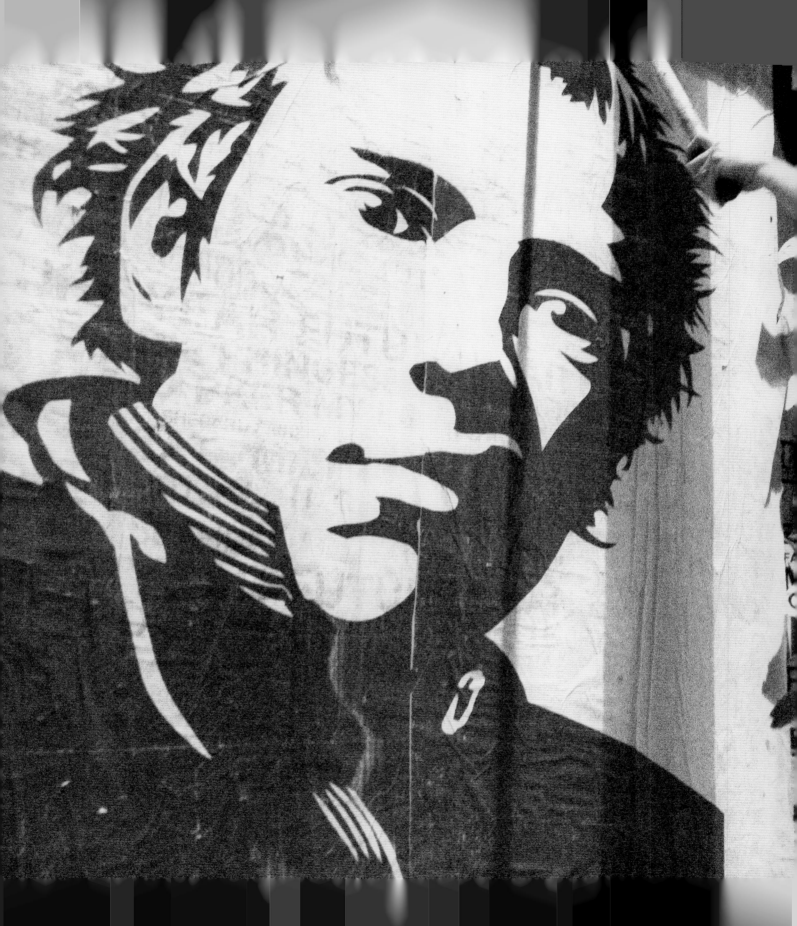

SHEPARD FAIREY
ON $ELLING OUT

interview by Dave and Holly Combs
photos by Mark the Cobrasnake

It's difficult to discuss street art at any length without covering the work of Shepard Fairey who is viewed by many as the Godfather of modern street art. Though he takes no credit for inventing the methods he's employed over the past 17 years to spread his worldwide OBEY propaganda campaign, no one could reasonably argue the position that anyone has taken those methods to the level Fairey has. The argument begins as soon as the topic of selling out comes up. Has Shepard Fairey sold out? It's a divisive issue and even the most objective observers when truly honest find themselves in one camp or the other. The American Heritage Dictionary defines a sellout as, "one who has betrayed one's principles or an espoused cause," and levelling that accusation at an artist is perhaps the most aggressive form of attack on an individual's artistic integrity. Now that the OBEY coup has invaded mainstream department stores the sellout cries are louder than ever. To answer his critics, PEEL magazine asked Shepard to tell his side of the story...

Why do people call you a sellout?
I think people call me a sellout because they're so conditioned to thinking that if something gets larger that you have to sell your soul for that to happen because it is so difficult especially in art. It's so difficult to make it as an artist that there are a lot of people who can't ever accept that if you do make it that you didn't work with evil forces and sell your soul in some sort of way. There are a few fundamental things that it all boils down to for me that have made me choose the path I've chosen. They're really really simple. One is, I'm a populist. I believe everyone should have access to things that are intellectually challenging, aesthetically stimulating, high quality, but shouldn't have to pay a lot for it. Therefore, I want to make it accessible. Whether that's putting stuff up on the street, or offering it at a reasonable price as a poster or a t-shirt, I want to make what I have accessible. People want things that connect them with the culture they relate to. Seeing art on the street is great but everybody that likes something they see on the street would also like to have something that shows their connection to it. So whether that's owning a sticker, a t-shirt, a screenprint, that's the reason my book is called Supply and Demand. It's because once I did my thing on the street, people started wanting it. One of the first things that I realized, was people were making "bootlegs" of my stickers that were derivations, or tributes, or homages, or making fun of my sticker. It was causing a reaction culturally, but as well there were also people that were just trying to exploit the resonance that I had created with what I did.

How do you feel about that exploitation?
It shows that what I've done has made an impact, and that's what I set out to do. So it's gratifying in that way, but also for the years and years that I spent completely broke spending every last dime I had on making stickers and posters and stuff, to have someone once it reaches a level of resonance come in and exploit that for their own gain and not have me benefit from it is not just in any way. The weird thing is that people say, "That guy sold out." People that try to sell out exploit a trend that already exists to quickly cash in. They don't nurture something for ten years. Everything I built is because I believed in what I was doing, not that I ever thought it was going to be about financial gain. The financial gain in my opinion is a by product of sticking to my guns and doing it right. There are so many people that get inspired by something and they don't have the tenacity to stick it out and they never get anything out of it. Or they just try to jump on some bandwagon, and they get some quick payment, but they don't build anything that can endure. The interesting thing about street art is just how critical people are of their own community. I know some people get more mad about Neckface doing a t-shirt than they do at George Bush invading Iraq.

Isn't that type of thinking inherent to underground cultures such as skate, punk, and even hiphop to some degree?
The sort of sellout idea? Well, in hiphop it's like, "I'm going for mine," and everybody loves that. There are a few people that are sort of grumpy like De La Soul or whatever because they never really hit it as big as 50 Cent. I've made the decisions I've made and I've never had sour grapes if I've paved the way for Banksy to sell a painting to Christina Aguilera for fifty thousand dollars, or Neckface to sell out art shows and get the cover of Thrasher. I'm happy for them. I always feel like whatever those people are doing has its own merit. It fits within

the zeitgeist in a way that's working. And I have nothing but good feelings towards people that are doing well. The thing that's really interesting about punk rock is there's that whole sellout thing too. And that's my background, punk rock and skateboarding. But the other component of it is that people who skate and are into punk rock wear the representations of their culture as t-shirts, buttons, pants, their hairstyle, everything. It's like sending out a beacon call to people with a similar cultural interest, like, "This is what I'm about, I'm representing this. Are you down?" In the 80's if I saw another skateboarder, somebody with a Santa Cruz or Independent t-shirt, I ran up to them to bond with them because it was such an outsider community. The interesting thing is that the very items that made those people connect with each other just at a glance, are the exact same things I'm being criticized for now. Independent sells millions of t-shirts in Pacific Sunwear and I never hear anybody saying they sold out.

Do you think it's jealousy from people who don't have the tenacity to follow through on their path in the same way you have?
Yeah, absolutely. And for a lot of people it's ignorance. A lot of them are just naïve. An example is a guy I used to skate with in San Diego, a graffiti artist. I saw some of his work and I was like, "Man, you should do skateboard graphics." He worked for a shoe company and had some in roads. He was like, "Fuck that shit! I'm never gonna put my art on no skateboard, that's sellout." Then three years later he's offered a skateboard company to art direct and his art is all over skateboards now. It was this, "I don't want to be a member of a club that doesn't want me." He was too scared to put his stuff out there. A lot of people do graffiti, including me, because there's no fear of rejection. You're imposing it on people whether they want to see it or not. You don't have to go and sell it, do your song and dance, "What I'm doing has merit, please show me in your gallery, please hire me to do something for your company."

When things of an underground origin reach a certain level of mainstream acceptance, it seems without fail that people within that culture begin to criticize. Why is that?

It gets back to what I was saying before, I'm a populist. Even within these underground cultures, there's a level of elitism that makes me sick. It's that when I'm one of the few people that know about Neckface or Banksy or whoever and they're the new hot thing, I'm into them because it's something that makes me superior. When they don't have stuff that's accessible to other people, whether it's geographically I live in New York or I live in London so I have the inside line on this stuff, and I can brag about how I'm in this exclusive club that knows about these people and have access to what they do, that's great. As soon as more people do, I'm no longer superior, and I reject that and I move on and look for the next thing that makes me superior. This is a reflection of people who have nothing to offer, they just leech onto other things. This elitist attitude comes from not having anything to offer themselves so they have to kind of project onto other people what they wish they were about.

It's kind of like Banksy or Shepard or whoever, they're a martyr for street art. They get no gain and It's almost like a Jesus Christ situation. Someone else suffers to absolve me of my sins. That's really creepy to me and I will never do anything to foster that mentality.

Why is underground seen as having integrity and being good, and mainstream as being inherently bad and being sellout?

It's because typically people controlling the mainstream totally suck, and all they care about is making money. However, if one were to be able to raise the bar for popular culture altogether and have a situation that was more mainstream and still good quality... the analogy I always make is the Beatles. You can't fucking front on the Beatles. They made good music. They made challenging music, especially in their later years. It's like the smartest person in the room and the dumbest person in the room could dig what they were doing. And if you didn't like them, it's just cause you're player hatin'. Even if it's not your cup of tea, you can't really front on the quality of it. You know what I'm saying?

What is it that holds people back from going bigger or being a full time artist?

There are a lot of people that their insecurities about ever striving to do something to take something to the next level make them boohoo anything that does or they just don't think they want to deal with it. There's a lot of things holding them back. It's human nature to justify the position that you're in and to try to downplay why you haven't had more success. Especially with street art it's really difficult to succeed. Every single artist that's doing stuff on the street, if they weren't trying to communicate with an audience and have a voice and do something creative, which I'd imagine they'd rather do full time than work at a shitty job, then they're lying to themselves. Otherwise they wouldn't be bothering with it.

I'm totally lucky that I come into the office and work on art all day every single day. It's still a lot of responsibility and a lot of stress. And that's not to mention the years and years of living at the poverty level and just busting ass. I've got no apologies because I've already kept it real for so fucking long. Things have an arc and if something stays underground forever a lot of times that means it's not that good because it doesn't find a fan base. If something is really good, it's going to resonate and it's going to find a fan base.

Now that PEEL magazine has wider distribution and a growing fan base, sometimes we hear similar criticism.

What they're saying is, "Oh my god, a doctor could walk into Borders, pick up a copy of PEEL and go and do street art, and we don't need any more people." Or something like that. My attitude has always been the more people who get inspired by what I call alternative culture the better.

Whether it's punk rock music, or skateboarding, or street art, or hiphop, or zine making, or whatever the fuck. The more people that get inspired by that rather than sitting back and letting MTV spoon feed them their lives, to me is vastly superior.However I've noticed just with my friends that are in street art, I don't necessarily get into a debate with them every time it comes up, but my posters have been up for a long time, and then somebody new comes along in LA or New York that's doing posters and people are like, "Aren't you bummed on all these biters?" I'm like, "Come on, I didn't invent wallpaper paste and posters. I'm not the first guy to ever do it." I was inspired by Barbara Kruger, by Robbie Conal, by numerous graffiti artists, and then my inspiration manifested in the form of posters. Just because people are doing something doesn't make it a bite. There's room for plenty of people in this world. I like seeing more people up. If I see something that's boring or derivative I hope that in the process of doing it that person starts to evolve a little bit and take it into their own direction. But I'd definitely rather see

people out there doing something even if it's not that good because then there's going to be a learning curve. It's all trial and error. If you're not doing it, you're not going to improve. A lot of people are paralyzed by their fear that they won't be good enough, and they'll never get any better because they'll never practice.

Have you experienced that trial and error growth personally in your work?

I look at some of my early stuff and I'm kind of embarrassed by it but at the same time, it was part of the evolution to where I am now. I think most of the work I do now is pretty graphically sound.

When did you first start hearing the cries of sellout?

A lot of people were down on me for having a graphic design career even starting in '97 which is when I went into it full time. Prior to that I was running a screen printing company. The weird thing is that even at that time, when I was like thirty thousand dollars in debt, people were like, "Why are you selling out doing graphic design?" And they thought that exposure equals money, and even though I'd been in magazines I was still in debt. It's just the idea that as an artist you'd even work for anybody else besides yourself makes you evil. Well the Sistine Chapel was commissioned by the church. That was a paid project. (laughs) It's no different from like doing an album cover now. My response to all those people was when I was working as a screen printer I was working for people printing karate uniforms and stuff for pizza restaurants and shit to which I had absolutely no cultural connection, and that was just so I could make money to do more street art stuff. To me I was compromising way more then than when I started doing graphic design because the graphic design I was doing was for skateboard companies, street wear companies, album packaging, and people that I actually had a cultural connection to. And my strategy with doing graphic design was always like, at least I'm honing my skills as an artist and designer even if I'm doing stuff for other people. And I'm generating money from that which means that I don't have to kiss the ass of the fine art world with my art. That I don't have to worry about how many posters I sell, who I piss off, who I please. I just do what I please. So the content of my fine art was never affected by market forces in any way. So for me to have an inside outside strategy like that there was no compromise where it counted. And where it counted was my street art which was also my fine art. My goal was always to keep it as pure as it could be, and not have to be like, oh shit I gotta hustle to sell some posters. That's something that I think is all about integrity and no compromise, and that it would be something that would turn around and bite me in the ass is totally ironic to me.

What about more recently?

Anybody who's calling me a sellout, all they have to do is look at my fucking book. It's seventeen years worth of work. Anybody who would question how street I've kept it should take a look. There's huge street installations from 2006 in there and it goes all the way back to 1989. Name one other artist that's done work on the street for that long. Haze did stuff for like two years, Futura, three, maybe five years. It's like all these guys that totally have respect, I don't know how these guys like Futura and Haze have avoided the backlash. Maybe it's because these guys aren't as visible but they both have clothing lines, they both do corporate design gigs. Personally, I wouldn't work with Nike. I'm not a fan of Nike, but they've both done stuff with Nike, and that's usually a big sellout target when you do stuff with Nike. Except for this weird phenomenon of the Sneaker Pimps type people who support Nike, but they totally hate sellout shit but then they spend like two hundred dollars on sneakers. There's a lot of hypocrisy. But I try to stay positive in all this and just keep it quality and do what I do rather than dealing with the haters because it just saps your energy. But we are on the topic so I'm gonna call a spade a spade.

Some time ago you were quoted as saying, "Fine art is dead." Now it seems that things have come full circle and not only fringe galleries but influential galleries such as MoMA are showing work from the street. Do you want to speak to that at all?

Sure. Trends in art come and go, and I don't really trust the fine art world so I don't put all my eggs in that basket, but as long as what I'm doing isn't catering to an elite fine art crowd, if it's embraced by the fine art world, so be it. There's nothing wrong with that. My attitude is that I'm going to use all the machinery at my disposal to try to get my messages across. And if some people think that the message itself is corrupted by the medium, and they think that work in the street is great just because it's on the street even if it has nothing to say – that's stupid to me. That's like saying the fact that it's out there on the street makes it good even if it's not. But I would still tend to agree with that more than thinking something in a gallery is good just because it's in a gallery. I respect the street as

I've got no apologies because I've already kept it real for so fucking long.

a tool of empowerment, and use of public space for freedom of speech and expression. There is this weird thing where if you show in a gallery, that somehow corrupted the art. But it's just another medium for exposure, whereas a t-shirt is another medium for exposure, where putting your stuff up where you know a television show is going to be filmed so it shows up in the background is another medium for exposure. They're all just different tools in your arsenal, where saying you're only going to use the street is kind of narrow minded. I always say, "By any means necessary." And when the only means at my disposal was the street that's what I focused on primarily and I still do a lot of stuff on the street. But in a gallery where I or any other artist can make a controlled presentation, get their ideas across and also take advantage of the machinery of that world, then the MoMA is going to influence magazines to cover it. These are just part of the trickle down to get the work to the people and all of that is really important. The thing you don't want to happen is you don't want the fine art world to be controlling your content because they tell you, "This is what's going to work, and you're not going to get to the people without us." I've obviously already gone around that, and I'll embrace it while it's working for me and if at some point it's not working for me, I'll do something else.

Even doing album packaging or posters for bands or skateboard graphics, I get to put a piece of myself into every single one of those projects. So that's a secondary tier where I'm satisfying the client's goals, but I'm also satisfying my own. Every single thing I apply my art to I look at as a way of getting it out. The fine art world is just one part of it. Everybody likes to make these distinctions, but I think since the pop art movement there really isn't much of an aesthetic distinction between what is fine art and what could be like video game packaging. To me it's a lot of semantics around context, and if you're putting a message into something that's a little bit more mainstream a lot of times that's way more fucking subversive than like, OK, I know people who already think like I do will come to this venue and look at the art and we call all fuckin' jerk each other off and nobody who would have really benefited from seeing the stuff who didn't agree whose perspective may have been shifted by the work has seen it and it just exists in a vacuum.

At your recent book signing in San Francisco the crowd who showed up wasn't necessarily who one might expect to see, but more of an uppity crowd. How do you respond to things like that?
It was everything from straight up graffiti thugs to a couple who was in their eighties. There was a lot of diversity. I think the thing about my work is it's not cryptic, or designed to be only understood by the graffiti community or the street art community, where you have to have studied the vernacular of that world for

many years to be able to understand it. I don't want that anyway. And once again we're back on that topic of that subcultural elitism. So if somebody showed up and they were bummed out because there was a diverse group of people there and it wasn't just street art people, then it's the phenomenon of, I liked Nirvana when they put their first album out and only twelve people from Seattle knew about them. But then they put out an album that was really amazing but a lot of people liked them and so now they sold out.

Subculture has been exploited so much by the mainstream that now people just want to keep it super exclusive because they have this fear that it's just going to get watered down and ruined. But I think that if something genuinely affects people it can't get ruined. No matter how many people try to cut stencils like Banksy or design like I design if the work makes an impact those copycats can't ever be the original. There's no way to ruin the quality of the original. Hundreds of people try to paint like Michelangelo but you can still tell it's not the real deal. I think if something's really good it's always going to be valued by people. In the short term, all the sellout stuff kind of bothers me, but I think that in the long term my work will stand. Keith Haring got a lot of criticism for the Pop Shop in New York and doing calendars and stuff, but he's seen as somebody who critically pushed street art forward in his time and took it to the fine are world as well. And Basquiat did the same thing. And the reason that his work is worth more is because he did less and died even younger, however, who's more familiar to the masses? Whose story is better known? I think Haring. I prefer him for that reason. He felt guilty when his paintings were selling for a lot of money. When Tony Shafrazi sold a 14,000 dollar painting, Keith Haring went and made 3,000 offset prints of the same painting and gave them away in Central Park. And every gallery I've ever worked with would tell me not to do shit like that. Don't make multiples, etc. And the weird thing is that I actually have a feeling that a lot of my critics would shut up if I didn't make prints and t-shirts and all that, but then my work would only be available to rich people. And to me, that's in total philosophical opposition to what most of the people doing street art would say, that it's for the people. And people want something to hang on their wall. (laughs)

Can you talk about the Hot Wheels design you did recently?
Yeah, it was a limited edition thing for the Peterson Museum. They had this VW bus that they were doing and they asked me if I would do a graphic for it. I've been into the anti-war peace kick, so I did it like a late 60's hippie bus or whatever with some of my graphics. To me that's a cool item that's going to hit a different crowd than some of my other stuff. I think it was limited to 1,000 pieces. And the thing about that when people are like that's a sellout move, I hardly make any money from that anyway. I don't really care whether people think I'm making money off it or not, but my whole thing is nobody's making you buy anything. If you don't like it just don't buy it. It's not like I'm doing Best Buy commercials like the Black Eyed Peas or something.

What was it like being a character in a video game?
My interest in that was that all the other people in it were people who inspired me when I was coming up. I'm the only non New Yorker in the game and it's all people that put in a ton of work on the street and that were crucial in the development of graffiti culture. And I felt honored to be put in it because I was largely influenced by those people so it was a tremendous compliment. Street art is not permanent. It's something that might last for a day, it might last for five years, but it's going to be gone. Being in a game, in a way, at least that's preserving it for eternity for what it is. In the end, all that's going to be left is photographs because the art is going to go away. Also to reach an audience who might not be plugged into it, that's exciting to me, promoting graffiti.

The irony about the video game for me is that I don't even play video games because I don't sit around. I'm way too busy for that. I don't waste time just being entertained except for occasionally watching a movie or the Simpsons. I felt like if somebody's already into playing video games, then something that promotes something that's visceral, empowering, and rebellious that may get them off their fucking couch and out onto the street then that's a plus. Being that I'm the only wheatpaste guy in that video game, a lot of people that might be into aerosol graffiti for them that's cool to have the other guys in there. But for the people who might not relate to aerosol graffiti, to have me in there is another route to promote the idea of going out to do stickers stencils and posters. I saw all those things as positives. And all the people that are like, "Oh, that's a sellout move," once again the check from doing the video game thing… not that much. It was a few thousand dollars. It's not like Tony Hawk where I get royalties from the game. It's not really that much money. It was more the coup of being put in something like that and being sort of immortalized.

> If you believe in something you have to stick to it, because there's always going to be a million detractors... if you do give up then you're no better than that person and they like that. People like to feel like if they're being lazy, that they're not missing out on anything

Like getting up... virtually?
Exactly. That gets right back to my rationale of what I was saying earlier about getting my work out there by every single different mode that was at my disposal. There's an interview with me from 1992 from somewhere where they're asking, "What's the future? What would you like to see happen?" And at this point I had just upgraded to vinyl stickers from paper and was making a few t-shirts and basically subsistence living. I was like, "I want to make watches, and Izod shirts, and all sorts of weird stuff like that which will freak people out because they won't know what to make of it." And everyone was like, that's so funny, that's so subversive. But then when it actually happens they're pissed off. (laughter) Because it was the whole thing where I love the idea of that coup, but when it actually gains traction and it's not just a hypothetical thing, then they're bummed out.

Why do you think that is?
I think it makes some people mad because they like the underdog status and the whole community of saying, "Fuck it, I'll just have my shitty job and make a couple of stickers here and there because that's all you really can do, man". When somebody disproves that all of a sudden their whole half-assed attempt at anything they're doing is all shot to shit because it's been proven that it's possible and they don't have any excuse for not taking it further. I have no patience for laziness at all. I've worked really really really hard. There have been a lot of people I owe gratitude to for helping me along the way, but there wasn't some lucky break. There was just like, "OK, if that route didn't work, try something else, try something else, late nights, weekends. For seventeen years, and I'm still fucking going. I worked all Saturday and Sunday this weekend. Last night I worked until one o'clock in the morning. I just work all the time, and I enjoy what I do, but you're not going to get to where I am by going to Sticker Guy and getting twenty stickers done and maybe sticking them on your block, and then getting on the internet and shit talking, you know what I mean? It's just not going to happen.

Anything else you would say to those kids who might be looking to what you've done for inspiration?
It's gonna take some serious effort... and patience. Things don't happen overnight. Patience and effort. But the main thing that it takes is doing something that is unique enough to create its own niche. You might be working within an existing niche like poster art or sticker art or aerosol art, but you've gotta do something that is your own vision that's unique. If you're just trying to copy what's cool that's already working you're too far behind the curve to build your own thing. When I came out with doing what I was doing I didn't have any belief that it would go nearly as far as it's gone, but even then I was like, "I'm not going to do aerosol graffiti because that community's totally saturated. I'm going to do my own thing. Everything exists within a timeframe, a zeitgeist, and a context, and if you understand what that is and what you need to do to be relevant within that then you're going to go a lot further than if you say, "Well, twenty years ago, this is what worked for that person," then you've totally missed the boat. And if you believe in something you have to stick to it, because there's always going to be a million detractors. People say, "That's not going to work, just give up," because if you do give up then you're no better than that person and they like that. People like to

feel like if they're being lazy, that they're not missing out on anything. (laughs) And then there's a lot of jealousy when stuff does happen. I lived in San Diego for five years and that's a city where there's a ton of talent, and people aren't really capitalizing on their talent because they're too lazy. I'm totally stereotyping, here.

Isn't that the stereotype though, that artists in general are lazy?
Yeah, and I think the other thing too is that as an artist, I tend to hate structure and be somewhat antisocial. However, to accomplish what I wanted to accomplish I went against my own tendencies in order to take what I was doing further. I can have a meeting with somebody about doing a graphic with them, and I can show up on time, and I can be articulate about what I do as an artist, in order to negotiate shark infested waters with businesspeople. Not just being like, "Screw this, I'm a rebel artist anarchist." In a way I'm much more subversive than that rebel anarchist because I get what I want out of the situation without having to compromise. The person working for Warner Brothers doesn't realize that I'm satisfying my own agenda while satisfying theirs. To be able to deal with the things in that world that most artists don't want to deal with, that's already going to put you at an advantage in terms of making a viable career out of art. Some of it is annoying, but in the long run, I'm the one that's calling the shots, and even more so with the more things I accomplish. There's nothing that gives you more freedom than having something out there that's successful that's seen as a cultural milestone or whatever and then after that it's like you're opening doors doing things the way you want it done. Whenever I've done commercial art I've always done it in a style in which I wanted to be hired to do more work. Rather than being a style chameleon, I've always done it my way. There's a balance between being an uncompromising impossible to work with asshole and doing things where each door that gets opened and each barrier that gets broken down, it gets easier and easier to do things your way and have it on your terms every time.

To sum it up would you say that you do what you love doing, you do it your way, and you get paid?
Yeah. Anybody who says you're not a real artist if you're not suffering, well I already did that suffering for a really long time, so I think at some point you know... even Catholics get to leave purgatory at some point, right? Once they've paid their dues. The weird thing is I don't even need to do street art any more as part of my career. I don't need to do anything that revolves around independent culture at all. I don't need to do a magazine that puts a spotlight on other artists. I don't need to do a gallery that shows emerging artists. None of that. If it was about selling out, there's tons of other things I could be doing that would definitely be a more expeditious way to just generate more revenue. But that's not what I'm into.

The title of your latest book Supply and Demand suggests the relationship between currency and value. Would you like to speak to that concept?
The funny thing about that is that maybe some people think I'm seriously saying, "Yo, I got paid off this shit." Supply and Demand is an economic term, but it's also a reference to cultural currency. I created cultural currency for what I had, so that then I was able to make actual money off it. But perceived value and what gives something its value is something I address in the book left and right. That as something gets more popular it actually has less value to people that want to be part of that secret handshake street art club. But that's fine because that's not the people that I'm most concerned with reaching anyway. It never has been even from the beginning. That a lot of people in the graffiti world that I respected liked what I was doing was really cool, but it was never a goal. You know a lot of it is that, "What are my peers going to think?", mentality that holds people back. But you know the funny thing about calling the book Supply and Demand is that a lot of what I have done has been to address the concept of value. There are going to be a lot of people that are going to be too stupid to look further into it to realize that, but it's kinda funny. If I'm misunderstood, it's usually by people that I don't care about that much anyway.

for a further look: www.obeygiant.com

EXCUSADO PRINTSYSTEM

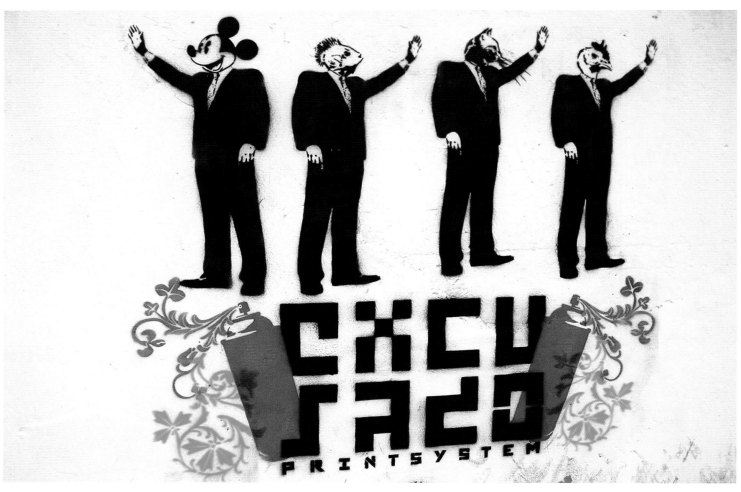

interview by Aimee Maddox

Excusado Printsystem was established three years ago.
What was the driving force behind forming the crew and using street art as a form of expression?
From the very first moment we got together in order to make a fanzine, April 2002, we felt like we didn't want to work on graphic design just for the money or joining a well-known advertising agency. Above all stuff we are good friends, we met each other while playing soccer and we started working on practical and simple reproduction techniques. We started with the fanzine (number 1,2,3) then we decided it was about time to face the streets, first with posters, stickers, stencils, then our interventions increased in quantity and size. Now, I think our driving force has always been curiosity, that people can see our work out there and challenge rules, first at the university, now in the streets and collective thought.

Each of your four members has acquired nicknames (Stinkfish, Deathbird, Saintcat and RatsonRop.) Where did these monikers come from?
These nicks were taken as word plays, animals, and qualities. Well, ratsonrop is a composed nick and it can be read in different ways. The idea came out when putting the word "pornostar" backwards, then it shows the words rats, rat son or dead rat (multiple personalities). These alter egos show definitions and features that really fit us and they are even much funnier than our "Christian names".

All of you are graphic designers and hold jobs at prestigious companies such as Vogue, Sony and Saatchi + Saatchi. Would you say you lead a double life?
This is a fake double lifestyle, Excusado is made of parallel stories that get mixed up from time to time, some are real ones and some others come up when we get together to have some beers. When we developed our fake profiles we never thought of working for huge companies; however, Excusado is still working on projects that get closer to that hidden story and it still allows us extend the myth.

Are you pretty secretive about your alter egos?
We try to stay undercover, by keeping low profiles and our work as top secret, but there have been more people around looking for us, we answer interviews, help school research, rehearsals, home videos, we get into lectures and conferences so in the end, the only way of keeping ourselves out of the spot would be by being covered with masks.

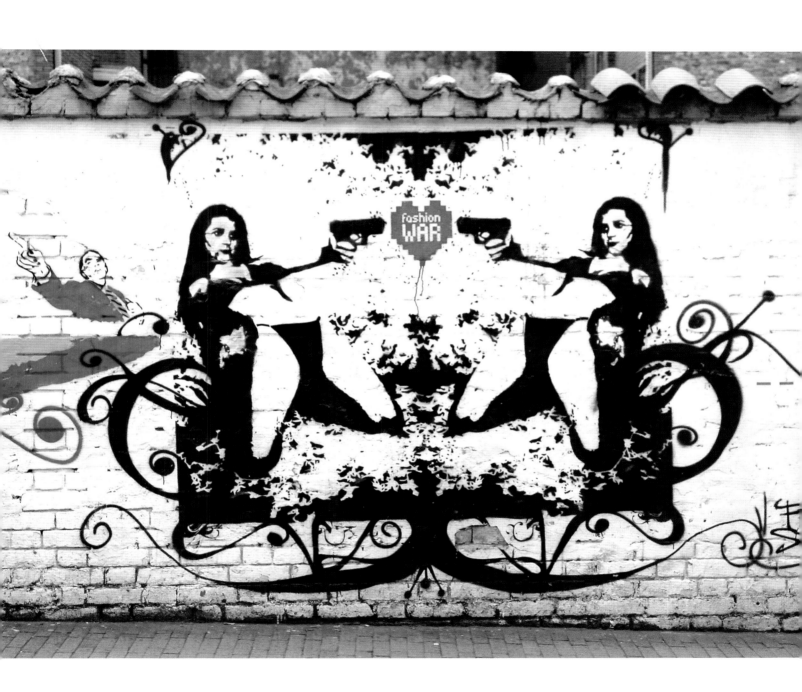

Observing your work, there seems to be several different styles and focuses such as eroticism, death and political propaganda. Is this due to four different opinions and interests or an evolution of your work over the years?

Our work was born in the middle of our great friendship; it is based on our most morbid and liberal thoughts and taste. We have developed different kinds of aesthetics to express what we really want to express. It is a mixture of independence and teamwork really. We could also say that this way of working would only be exclusive for us, as a result of the different research we began four years ago by using several kinds of means and techniques, Nowadays, we can notice some evolution in the way or working with stencil, this came out through experimentation and practice. It is possible to say that we are in a path that may lead us to big surprises, new shapes, new sizes and new basis.

There is also a strong concentration on children. What is the relevance of their imagery in your work?

We use the images of children thoroughly as a way of looking for a permanent space and cultural memory in the streets. Nowadays, Bogota is a rookie in street

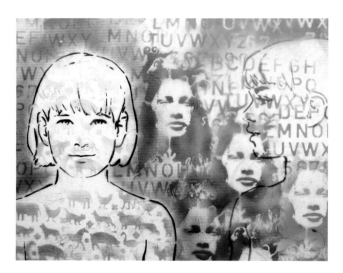

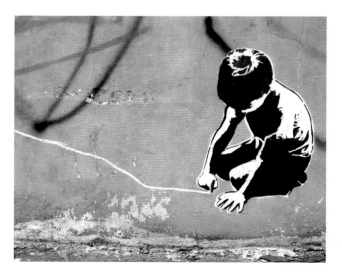

art, the image everybody has about the streets is related to danger, chaos, bravery, beggars and fear. It means, streets are home's foe, the caring and protective place. Through our stencils, we try to show the streets as the place for community and cultural setting, through images that bring us back to those moments of innocence and calmness as childhood, and give asphalt a friendly face image that invite people to walk around it and discover it.

One of the attributes of Excusado that I find refreshing is that you have involved the community, especially the youth, in some of your projects. How did this begin?

When we began to make street art, we realized that any proposal in this field was original and new. The main problem has always been to be recognized because of our work by not confusing us as vandals and end up behind bars. So we started to make workshops about basic techniques on reproduction, stencil and graffiti, first by having invitations to schools, universities, neighbourhoods and cultural events. The work is mainly made with children, teenagers and grown ups, we call people so they can work with us and we try to show our work in non-conventional places, trying to link as many people as possible, no matter what their taste is.

What are your intentions involving the public?

We didn't plan to involve community into our experience; it is something we have been discovering on a daily basis. Every time children reach out to us when we are working, we notice that street art has become a way of expression for ideas and community setting. From the intervention of a political practice (painting in the streets) beyond the message or the content, we try to invite others to own the techniques, to encourage independent ideas to have their own development and results.

Has law enforcement ever intercepted with your involvement in the community or in the making of your art on the streets?

Our work has led us to develop projects to influence the entire city by means of the local government. By always keeping our independence, we create an expectation campaign about the discussion on youth public policies. Besides painting, we have also developed workshop and lecture projects in public schools and institutions that work with youth and adult population. Nowadays, we are arranging a bit of "Desfase Segundo Asalto" (Desfase Second Round) with some of the local government's administrative tentacles.

You have made statements in other interviews that no one is to be out on the streets alone for safety reasons. What type of "dangers" have you encountered?

The main problem is that people do not recognize our job and they tend to confuse it with bravery. Our inconveniences come from authority, which still follows orders of filling up jails with people kept as a preventive way or looking for a bribe in the cold city night, they regard graffiti makers as an evil group that paint without any permission and damage private property. These piglets don't show up unless their slaves, private security, number two issue, who are watching from their spots, report "the appearance of a group of suspects with paint and stained hands" and in some extreme cases, they just stop us by attacking in groups with watching dogs and bikes.

Gang violence and the tagging of their territory are prominent in Bogotá. Has there ever been a confrontation with gangs while creating your your artwork?

No, actually we have had a good way in into the writer's scene. Graffiti is not part of violence among gangs, they tend to use the tagging, it's true, so those issues are worked out through painting, so there are some events developed so that painters and crew are called, there are self arranged competitions where there is a jury, rules are set and a final verdict is given. The first times we attended these festivals, we were guests, showing a remarkable difference between graffiti and stencil graffiti but nowadays we get into the competitions as an only category beside them.

Whose idea was it to produce Desfase (a street art exhibition) and what artists were invited to participate?

The idea of "Desfase" is to join the artists that are reproducing the street art scene in Colombia and Worldwide for two months, to show these works in the middle of an environment of interchanging ideas, product presentations, fanzines,

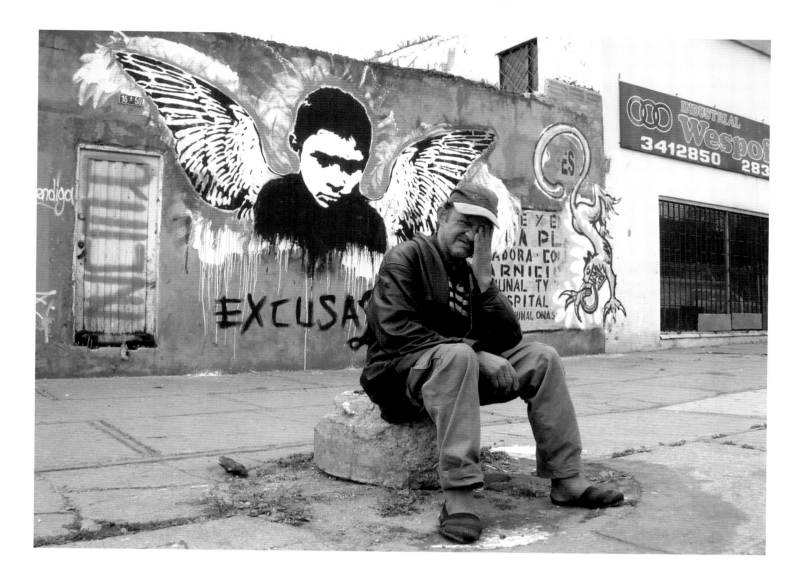

stickers, stencils, posters and apparel. Desfase is made of the visual and marketing samples, seminars (workshops/lectures) about street art. It will be the most important event about graffiti in Colombia this year. For this year, we have some artists from Spain, USA, Mexico and Brazil, besides Colombian artists from Bogota, Cali and Medellin. This is still quite a confidential project. We can just let you know that it will take place in November 2006 and we already have 30 confirmed artists.

What can we expect from Excusado in the next 5 years?
All the results we have gotten with Excusado, (first fanzine, then street art, now trends, then worldwide mental protection) can show us that there have been more surprises than plans. In the years to come: Rats will buy a couple of factories in south Asia, Insane Cat is sued for harassment to a fan, Stinkfish is converted into Quantic Presbyterianism and will found his own church, and Deadbird will have large family and will have to work from sundown to sun dusk until he wins the lotto and he can finally afford a mansion in the Mediterranean. No doubt, you will certainly have news from us, good luck and see ya.

for more visit: www.excusa2.tk

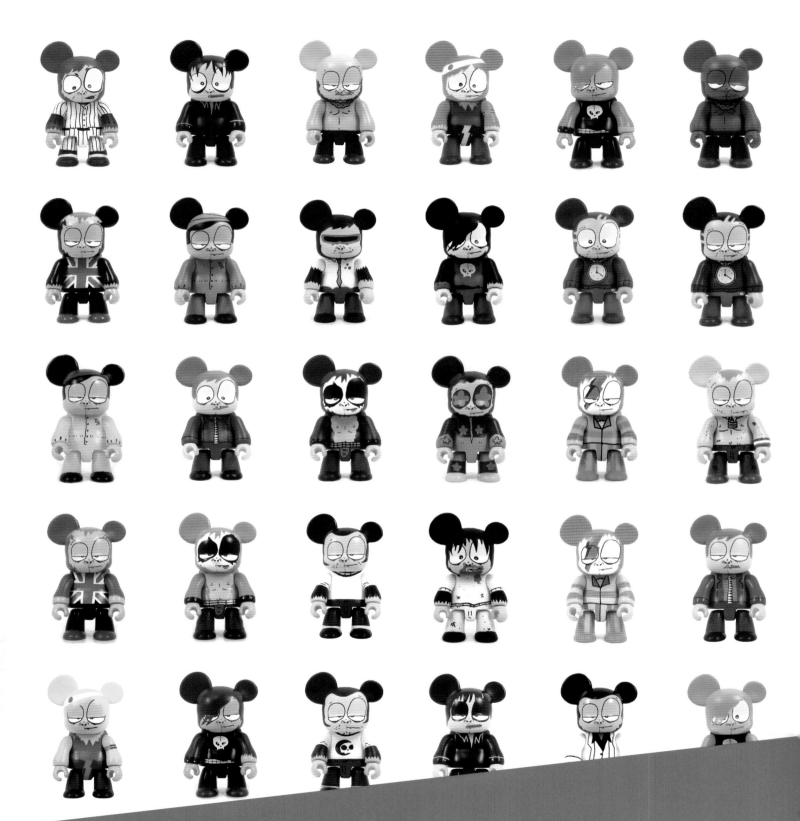

left page: MCA Evil Design (Issue 8)
right page: (left) MCA Evil Design (Issue 8)
(right) My Little Cthulhu by Dreamland Toyworks

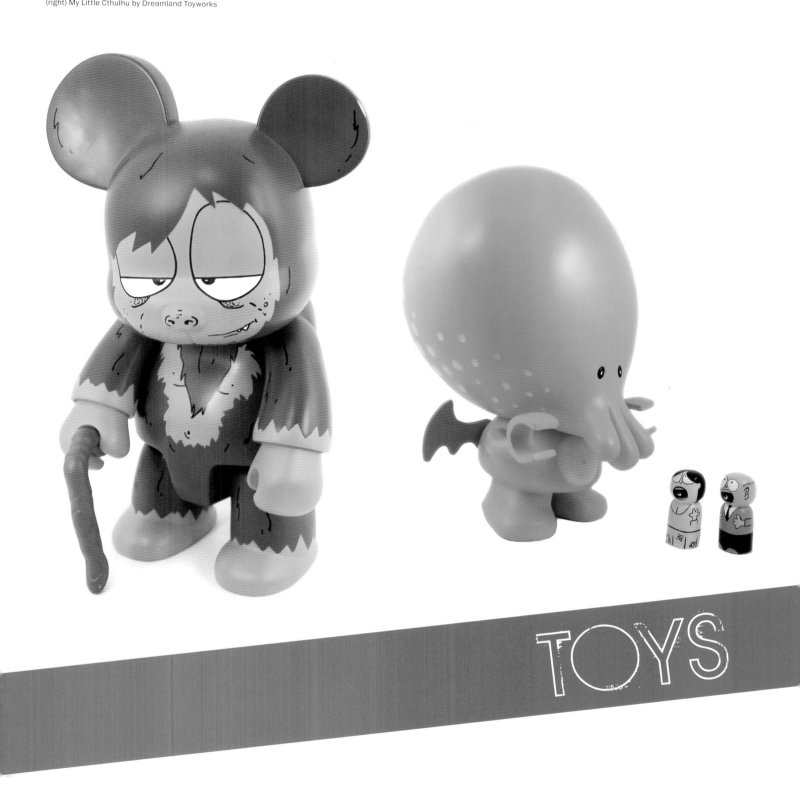

TOYS

left page: (top) Disposable Hero (Issue 8)
(bottom) The Hoodiez by Dreamland Toyworks (Issue 8)
right page: (clockwise) ZEEL (Issue 8), Koonin Family Pets (Issue 8), Ezeart (Issue 8)

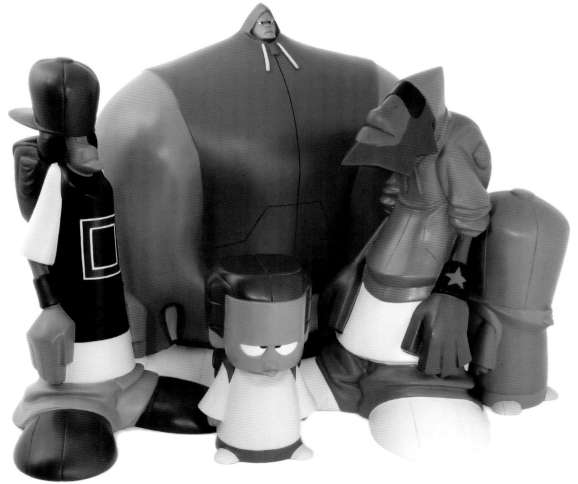

142

How do you feel about the younger generation of street artists using media like stickers, stencils, wheat paste, and the like?
I love it. I think it's great and I'm all for it. It's new and refreshing and a sign that the times are changing. It bothers me when I hear "writers" bash it because they're illegally showcasing their creativity on the street with just as much courage as the next person. No matter what medium is being used, it's still a form of graffiti. The bottom line is they're leaving they're mark.

Is the new street art historically part of what began back in the pioneering era of '69-'74 or is it something different altogether?
Of course it's a historical part of what began back then. All of today's modern street art finds its roots in NYC subway graffiti. It's illegal, right? It's art, right? It's about fame, right? So what's the difference? Content—and that's about it! You couldn't talk about one without mentioning the other.

Is there wisdom you'd like to drop on this new generation? You have a lot of their attention right now...
Don't limit yourself to what you know, always be open to something new. Don't be afraid to push the envelope of creativity and never be satisfied with where you're at—keep looking forward to that new horizon. But most important NEVER FEAR THE COMPETITION!!!!

A number of street artists are now designing art toys, so we decided to focus on them for this issue. You've done a Circus Punk, Qee, and your own Spraycan Monsters line. What led you to doing toys, and why?
I've always been a serious collector (of vintage toys) and that definitely helped me find my way into the toy designer circle. My obsession to collect and create toys stems from my childhood. When I was a kid my parents were pretty strict with making sure I was never spoiled—every Christmas and birthday I was only allowed to get ONE toy. Because I didn't have many toys to play with it led me to build all sorts of wild creations from scratch. I always had some concoction I was tinkering with. This hobby followed me well into my adulthood. As soon as I was older and had my own money to spend I was able to start collecting all the toys I ever wanted as a kid. In 1999 one of the guys I was buying toys from (actually it was Lev from Toy Tokyo) knew my history as an artist and introduced me to a Japanese friend of his who was interested in buying a piece of artwork from me. I invited him up to my studio to check out my work in person, I had no clue that he was a huge toy manufacturer in Japan. As soon as he walked through the door he ran right over to my filing cabinet where I had a few of my handmade toy prototypes. He went absolutely wild over them—once he learned that I had created them he made the suggestion of producing one of the characters as a limited edition designer toy. I was thrilled—it was the first character in my "Spraycan Monsters of Seenworld" series to be produced. In 2004 my partner Matt Doran and I launched our own manufacturing company PLANET6. We've added two more characters to the Spraycan Monsters series that are set to come out later this year and Mark Bode granted us permission to recreate The Bode Broad which is currently in production.

How about some of the other things you've done like Tattoos?
I started tattooing in the late 80's. I always liked them, I had a bunch of my own tattoos and I got the urge to learn the art. As soon as I started tattooing I immediately understood it—it just came naturally to me. I've been retired for a few years now but I still have my shop over here in the Bronx, right next store to my studio. But we'll save the whole story for the PEEL tattoo issue.

How about your work on comics?
I teamed up with the guys from Terminal Press, an independent comic book company, and created a few comics based on characters that I created. One of the comics is based on a series of gag toys I produced called Phony-Baloney. Basically the toys are a spoof on law enforcement officials—they're pigs dressed in police uniforms caught in some pretty funny situations involving anything from doughnuts to plungers! The plotline of the comic is based on the Annual Coney Island Hot Dog Eating Contest, that's why the title of the comic is "The Phony Island Fiasco". The second comic book to come out is based on the Spraycan Monsters of Seenworld. It's a basically the story of the Spraycan Monsters—who they are, where they came from, and what they do. My character is the narrator and I appear as a crazy bum sleeping under a pile of newspapers. It's great, I love it.

A while back you said you wanted to be instrumental in creating the first ever graffiti museum. What inspired you to come up with that idea?
Like I said earlier, I feel like graffiti hasn't gotten the respect it deserves in this country. We need to honor the people who sparked a world wide art movement—it would be the only right thing to do. If there ever is a graffiti museum it should be built right where it began—in NYC—the graffiti mecca of the world!

Are there any new developments along that line, and can you tell us a little about what the museum will be like?
Not right now—but when the time comes I just want to make sure that everyone is given a piece of the spotlight and void of all politics.

In as many interviews as you've done is there a question you've always wanted somebody to ask? If so, what is it, and what's the answer?
Why am I still here? ...And that's what I want to know. Ha ha ha ha ha!

for more SEEN... Tattoos: *www.TATTOOSEEN.com*
Toys: *www.PLANET6.com*
Graffiti: *www.SEENWORLD.com*

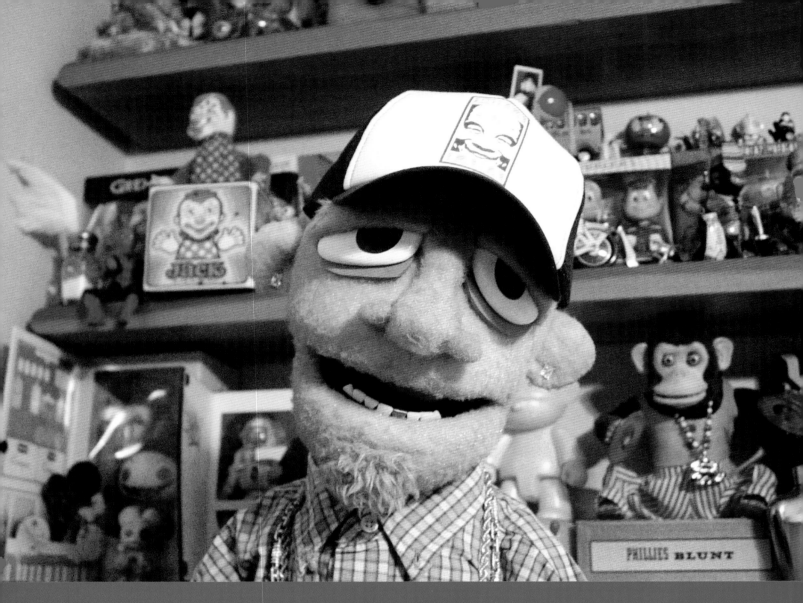

DOLLA:
MAKING SENSE
TAKING CONSCIOUSNESS TO THE STREET

interview by Dave Combs
photos by Dolla

Dolla first caught our attention a couple of years ago when he showed us his sticker panel collaboration project (appearing in PEEL #5). Since that time, we've watched his body of work grow and his style develop and mature. We've been consistently amazed by both his personality and his work and have been looking forward to the day we'd give him a proper introduction in the pages of PEEL…

When did you first start doing graffiti?
I started tagging around age 12 or 13. I would do toy names. The first mural piece I did was inside of my friend Jason's garage the summer before 8th grade. I thought it looked good at the time. The garage was a break dancing practice spot and hang out. I went through a bunch of names, but in high school I started writing ZIP and really started getting into drawing characters.

What was it that inspired you in those early days?
I didn't really know too many graff artists at that time. I would see a lot of killer graff when my dad would drive me into NY. There was a local spot in my neighborhood under the turnpike where the older guys would paint. There was an older graff cat in our town who went by FAT JUAN, I would try to copy his style.

Was it all about style for you or something else?
During my high school years I did a lot of tagging and throw-ups, quick ZIP bombs, and random vandalism. I was a junkie for the rush! Plain and simple. I just enjoyed fucking shit up, breaking stuff, setting fires, etc. Spray bombing was just

another way to vent (I did a lot of stuff I regret). At the time my drawings were separate from bombing. Bombing and tagging was just fun for me because it was "bad". I didn't do it for the art aspect or a message. Just rep. My biggest inspirations in high school were my art teachers Miss. Lombardi and Mr. Peters. Mr. Peters was mostly into making things. He would make some of the craziest animal puppets. He was preparing for his retirement. His plan was to do a traveling puppet show of Noah's Ark. I always liked puppets and Jim Henson's Muppets, but these puppets were total works of art, decorated beautifully. He was talented and a good person to boot. He nominated me for our school's art award which was a cash prize to go towards college. He also helped me graduate high school. After I was accepted into art school I found out I was in danger of being held back for not having enough credits. He spoke to one of the teachers who was flunking me and talked them into giving me a passing grade for the year so I could graduate. I was not your model student in high school, far from it. But I never skipped art class and I was always on my best behavior.

Can you talk about your time in art school?
In art school (Art Institute of Pittsburgh) I changed my tag to MORBID. I was really into horror flicks and just liked morbid things. There I met my friend KILO who was from Cleveland. He was a graff writer and he schooled me on technique and doing burners. We would go out and I would do his fill ins. I only did a handful of pieces on my own, but covered Pittsburgh with tags. There was this homeless guy in Pittsburgh who would do huge killer chalk drawings of faces under the bridges and around Point Park. He was a big inspiration. Some of my first big paintings were layers upon layers of sidewalk chalk with clear coats in between.

What came next?
I started dating my wife in art school and after graduation I moved to Orlando with her. I quit doing graff for a good eight years or so. I was focused on working; fabrication, drawing, and learning how to paint and what to paint with, in between partying that is. It was around that time that I developed a drinking habit. I painted a lot and partied a lot more. I wasted a lot of time with drinking.

When did you start showing your work off the street?
After some time of being a Friday drinker/Sunday painter, I got involved with a gallery (Gallery 223) that opened in downtown Orlando. My friends Jay and Rich had just started it and wanted me to be in their shows. They had a show a month for about six months and I was in every one. Jay and Rich opened my eyes to the "lowbrow" art scene going on in LA. They had all these back issues of Juxtapoz, and I would go through them all. I couldn't believe the art; graff, mixed media, sculpture, style, subject matter. Something clicked, like this is what I wanted to do. I was into Vangogh, Basquiat and Warhol at the time, and then got turned on to DOZE GREEN and DALEK's work.

When did Short Bus materialize?
After a good six month run Jay and Rich decided to shut down the gallery and get a studio, and asked if I would share space with them. Short Bus studios was born and I proceeded to get retarded with the drinking again. I was a depressed person at that time. I would go through sober periods where I would paint a lot and then start drinking again. I painted a lot of religious pieces and stencil art pieces. I started using spray paint a lot more in my artwork. We had the studio for three years or so, and we would paint for a good six months and then put on a big show in the warehouse.

How did you come up with DOLLA?
When we first started the studio in 2000, I started getting into making stickers. Rich was a screen printer and taught me how to print. I started making my own shirts and stickers. I started doing more hand made stickers and putting them out, too. That's when I started using the tag DOLLA.
A year or so earlier I helped a friend build a tiki bar in his back yard. We worked on it for a week straight. The first thing we put in there was a ring toss game where we would bet a quarter for the best out of three tosses. If it was a tie, you put in another quarter for three more tosses. I would always win the dollar pot so he started calling me DOLLAR BILL. Not very original, but it stuck.

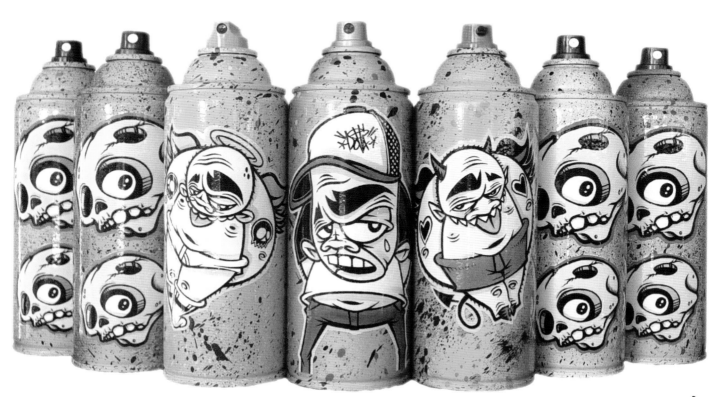

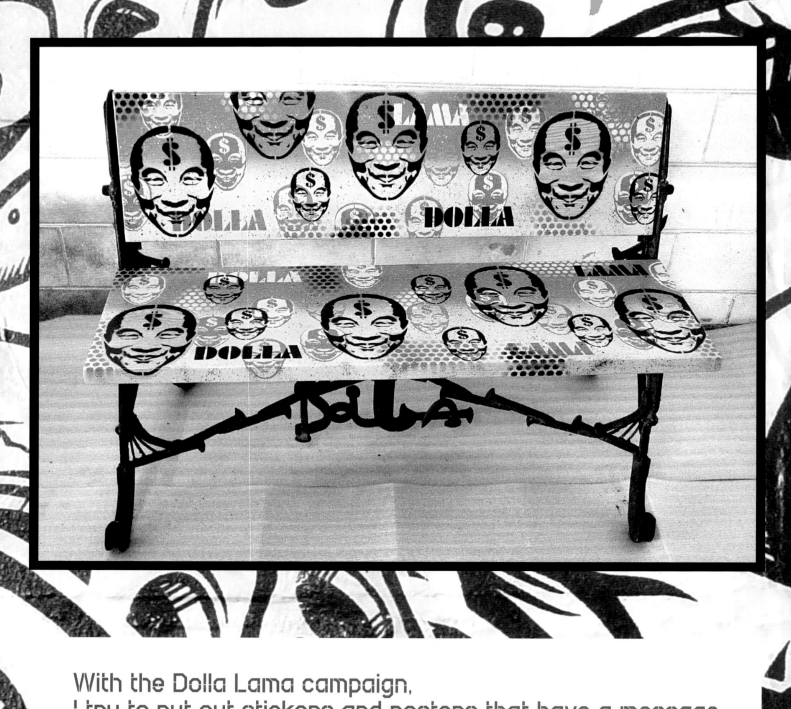

With the Dolla Lama campaign,
I try to put out stickers and posters that have a message,
something to think about. A lesson or words of wisdom that
can brighten your day or give you something to strive for
to make you a better person.

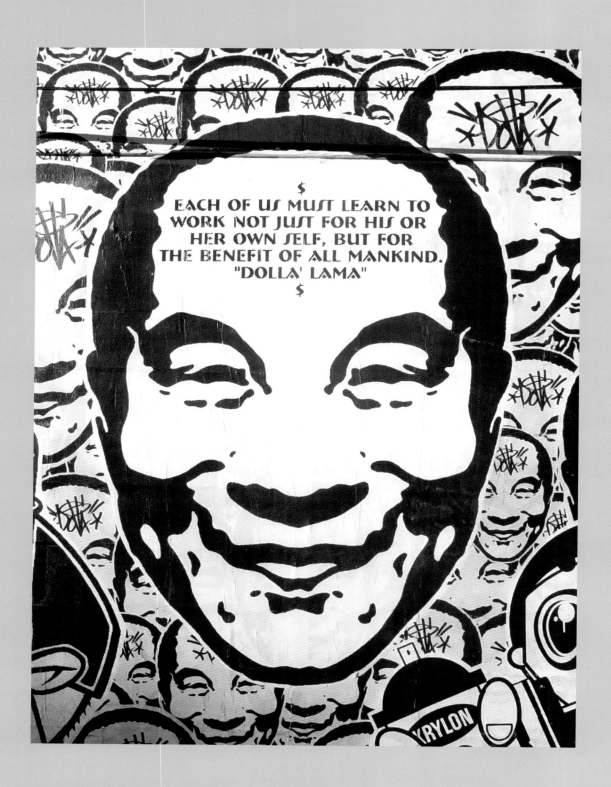

LUTHFI MUSTAFAH: Visual artist Luthfi Mustafah created The Killer Gerbil in 2003 as an alter ego—a street rat that kills empty spaces with colors and forms. The Killer Gerbil can be found on different surfaces using all sorts of mediums. Without any hidden or serious agenda behind this art, The Killer Gerbil's world is nothing but fun and for the masses to easily identify and embrace. The Killer Gerbil has been involved in numerous commissioned works, events and exhibitions both locally and overseas. His future plans include world domination and still keeping it real.
www.thekillergerbil.com

MISS MEGGIE: Miss Meggie studied illustration at the Willem de Kooning academy in Rotterdam, The Netherlands. She loves to make toys, dolls, murals, street art and paintings. Her biggest inspiration is her little daughter Noa.
www.meggie.nl

MUTI: Muti is the African word for medicine prescribed by traditional healers. We strive to provide local design representing the indigenous style of South Africa as an alternative to 1st world influences. Since 2002 we've been involved with clothing, illustration, stencils and stickers. For more info check out *www.muticlothing.co.za*

ZHINE: Zhine discovered the wild side of art in subway graffiti. He sees his art as "faith in Life," and wishes to open people's eyes with words and signs. Zhine considers the birth of his daughter Lola in 1999 as one of the greatest achievements of his life.
www.freetibetproject.com

PHALLIC MAMMARY: Phallic Mammary didn't have a problem with self-love. It was the type of thing that was hard to resist growing up with both sets of parts. Bold, empowered and always sexually satisfied, Phallic Mammary loves the nightlife, being on display, living it up and sticking to street signs the world over with her friends Coctopus, Squick, and Tit.
www.phallicmammary.com

THE PLUG: The Plug was born in 1978 in Belgium. He is a long time graffiti artist and is currently also a plastic artist. He created the "unplug concept," symbolized by the B&W plug paint on the floor. Since then, The Plug has developed more conceptual work, utilizing big canvases, neon installations, and wall paintings. He has worked with museums, art centers, galleries and collectors. The Plug likes to be discreet, but anyone who wants some information can contact him at *pnk_one@yahoo.fr*

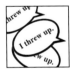

I THREW UP: I Threw Up is an experimental sticker campaign that strives to manipulate meaning by altering the multitudes of messages that surround us. It is an exploration of not only the process of implication, but the creative reclamation of advertising and public spaces. The stickers are designed to work like cartoon speech bubbles, and are usually placed strategically as to indicate speech. Target images are usually people, animals, or any sort of personified object or character.
www.ithrewup.com

CHRISTOPHER CHARLES AVALOS: Straight out of the 80s surf and skateboard sticker art culture of Southern California, Christopher Charles Avalos has been creating his eye-popping Pollock meets Warhol images for many years. From his love of sticker art he created his sticker trading project in 2005. Since then he has traded with well over 700 artists and has spread his love of sticker art all over the world.
www.stickertraders.com

N/PLYWOOD: N/plywood grew up in Yolo, California, where he's been making art with plywood for 6 years. He discovered this medium by accident: a hole was punched into a door, vertical strips where pulled, then horizontal lines were cut into the design. From there he's learned that he could cut whatever came to mind, such as bleeding hands, cigarettes, beer cans and other more complicated designs.

DR. BLADE: His name is Dr. Blade. He breathes the free air of Atlanta, GA. *www.drblade.org*

KLUTCH: Portland, Oregon's, Klutch has been continually creating visual mischief since his immersion in the early 1980s punk and skateboarding cultures, and he shows no signs of letting up anytime soon. His work has appeared in magazines from Thrasher to Time Magazine, as well as in the seminal books Fucked Up + Photocopied, The Art of Modern Rock, and The Art of Rebellion 2. These days he is best known for being the force behind Vinyl Killers, an annual show of international artists who paint on old records.
www.klutch.org and *www.vinylkillers.com*

ABOVE: ABOVE has more questions that answers. If you're looking for answers ABOVE suggests you find a math teacher. What is important in life? How do you measure success? Where has the fucking integrity gone? Who really cares? Why squabble at other people's lives? Where did the heroes all disappear to? What would you do if you had 7 days to live? At what point did you stop chasing your dreams? Why are you still reading this? Goodbye!
www.goabove.com

MILDRED: Mildred likes to drink and eat and skateboard. He also likes to draw and take pictures. Sometimes Mildred draws crappy on purpose because taking time isn't always fun.
www.unclemildred.blogspot.com

STEFAN HOFMANN: Stefan Hofmann lives in Bali, Indonesia, 7 months of the year and Seattle, Washington, the other 5 months. His current project is Spacecraft, a podium to set projects and ideas on, a place to interact with the world, initiate change and comment on cultural mythologies. Stickers serve as the vehicle for this project, a kind of mobile gallery. Stefan creates around 175 sticker designs a year and from those makes around 5 metric tons of stickers, only a fraction of which are sold. The rest are spread around the world through friends, mail, trips, etc.
www.spacecraftclothing.com

BILLI KID: An award winning Creative Director and published street artist. His functional sculptures and street art have been documented in numerous publications ranging from French "Elle Decor" to American "PEEL" magazines. His functional sculptures were a focus in Furniture Design for the 90s published by PBC International. His street art can be seen at *www.flickr.com/photos/billikidbrand*

EUGENE AND LOUISE: Eugene and Louise is a creative studio founded by Glenn D'Hondt and Sylvia Meert. In 2002, Glenn got his master's degree in Animation at Rits, Erasmus College of Audiovisual and Dramatic Arts, Brussels, Belgium. In 1999, Sylvia graduated at Egon College of Corporate Communication, Ghent, Belgium. Four years later she got her master's degree in 3D Design and Ceramics at Saint Lucas College of Science and Art, Antwerp, Belgium. The combination of their knowledge and artistic interests results in the fresh ideas found in the work of Eugene and Louise.

LUKEDADUKE: LukeDaDuke is a graphic designer, photographer and a teacher of the arts. He is also a frequent sticker vandal.
www.flickr.com/lukedaduke

THEYELLOWDOG: Ricardo Portilho aka TheYellowDog (Carangola, Brazil, 1979) started TheYellowDogNetwork in 2001, spreading dogs and love to various friends and contributors around the world. He is also part of the art collective Vesgo. In 2005, he moved to The Netherlands and joined the Masters program at the Sandberg Institute. Currently, he lives and works in Amsterdam.
www.theyellowdog.net/www.vesgo.org

SHIEKO: Shieko, from kuala Lumpur, Malaysia, worked in advertising for 5 years before tiring of it and moving on to freelance art direction, design and illustration. At the same time she did graffiti art as well starting with stencils and then characters.

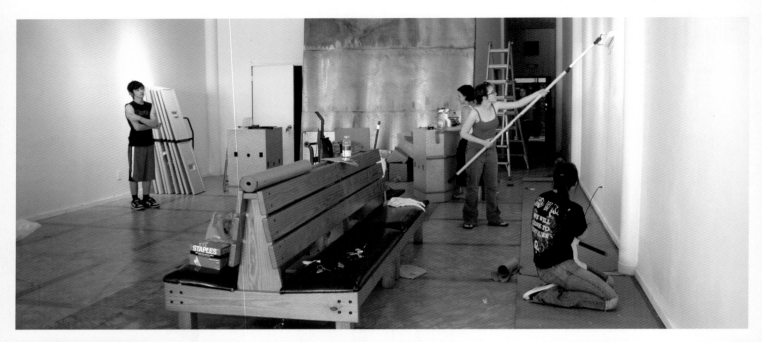

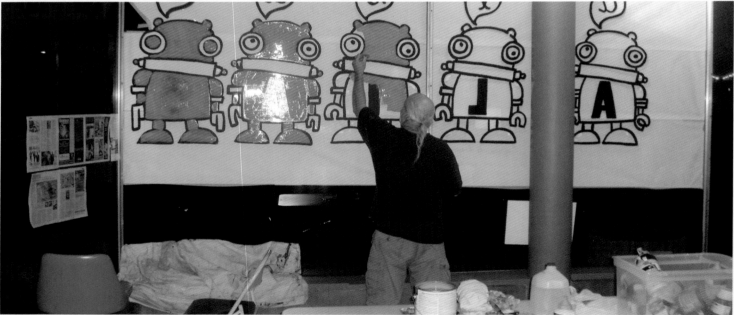

top: photo by Ivy Campbell, middle: photo by Mike Mayer, bottom left: photo by Angelica Espinosa, bottom middle: photo by Holly Combs

158

photo by Ken Sliger

DAVE AND HOLLY WOULD LIKE TO THANK:

God (the original Artist)
Shepard Fairey (for inspiring our ban comic sans campaign)
Chris of Robots Will Kill (for believing in the zine)
StickerGuy! Pete "Mench" (for making our first ban comic sans stickers)
Liz Farrelly (for Stick Em Up)
Marc and Sara Schiller (for Wooster Collective)
Josh Geldz (for Sticker Switch)
Evoker (for Urban Wallpaper)
Dom Murphy (for StickerNation)
Klutch (for Dez)
Zoltron (for ridiculous phone messages)
Black and BooksIIII (for roadkill)
Abe Lincoln Jr. and AnerA (for Stickerthrow)
Dad Sliger (for bagging all those stickers)
Clint Johns from Tower (for all the great stories)
olive47 (for maybe being in love with us)
me love (for inspiring our No Boys Issue)
Miss Venus (for kicking ass)
StickerTraders (for spreading the sticker love)
Dave Gee of MethodsNYC (for the killer release party)
Amir Fallah of Beautiful Decay
Mark Searcy and Brian Gibb of Art Prostitute
Peripheral Media Projects (for stimulating conversation)
You Are Beautiful (for being beautiful)
Mrs. Grossman (for stickers by the yard)

Logokillers and Blackbook contributors
Todd Ballard (for keepin' it real for so fucking long)
Brandi and our Ward Family (for loving us the way we are)
Michelle Pemberton & Matt Gonzales at INtake
Katie Kirkendall (for organizing our chaos)
Mike Mayer (for being willing to do anything)
Seaira & Alden (for hugs and kisses)
Pastor Peeler (for encouragement)
Mark Batty Publisher (for telling our story)
Shelly Fukushima (for designing this book)
Visa, MasterCard, Discover, and American Express (for financing)
...and everyone who's doubted (for motivating us to prove you wrong)

We would fill the whole book if we thanked everyone who has helped along the way, but you know who you are.

PEEL: The Art of the Sticker

Design: Shelly Fukushima
Editing: Jon Udelson
Production Director: Christopher D Salyers
Typefaces used: ITC Franklin Gothic, CamoSans, Major Snafu, Minimum ANoir, The Maple Origins

Library of Congress Control Number:
2007930506

Printed and bound in China by Asia Pacific Offset

10 9 8 7 6 5 4 3 2 1 `First edition

This edition © 2008
Mark Batty Publisher
36 West 37th Street, Penthouse
New York, NY 10018
www.markbattypublisher.com

ISBN-10: 0-9795546-0-8
ISBN-13: 978-0-9795546-0-5

Distributed outside North America by:
Thames & Hudson Ltd
181A High Holborn
London WC1V 7QX
United Kingdom
Tel: 00 44 20 7845 5000
Fax: 00 44 20 7845 5055
www.thameshudson.co.uk